P9-CEE-566

Frederic Taubes
# Oil Painting
## for the Beginner

# Frederic Taubes
# Oil Painting
# for the Beginner

**3rd edition: new, revised, enlarged**

WATSON-GUPTILL PUBLICATIONS          NEW YORK

FIRST EDITION 1944
    *Second Printing* 1945
    *Third Printing* 1946
    *Fourth Printing* 1949
SECOND EDITION (*Revised*) 1951
    *Second Printing* 1953
    *Third Printing* 1954
    *Fourth Printing* 1957
    *Fifth Printing* 1959
    *Sixth Printing* 1962
THIRD EDITION (*Revised*) 1965
    *Second Printing* 1967
    *Third Printing* 1971

Copyright © 1965 by Watson-Guptill Publications,
a division of Billboard Publications, Inc.,
165 West 46 Street, New York, N.Y.

*Manufactured in the U.S.A.*
*ISBN 0-8230-3275-2*
*Library of Congress Catalog Card Number: 65-15946*

*to all my faithful pupils*

# INTRODUCTION

Oil Painting for the Beginner has now reached twenty years since it was first published, and more than twenty-five years have passed since I gathered the material for its contents.

Now the question arises: is there a need to revise ideas that at one time appeared valid? To answer this, I should first state that my own knowledge was, at one time, based on the teachings of Max Doerner, with whom I studied right after the end of the first world war, and whose name then stood for "science" in the field of paint technology.

Alas, the science, as it appeared at that time, had not yet reached the level which exists today with the development of microchemical analyses of paint and painting media, a development used in examining the good old masters' works. I advisedly say "good" old masters, for we cannot look at them collectively as having invariably employed sound painting methods throughout the ages.

With the knowledge derived from the latest research in the field, many changes have taken place in regard to the value of using certain materials. Those who can look back half a century— or longer—know that the quality of the earlier paints was, in many instances, inferior to that of today. And consider paint thinners: the one-time favorite damar-linseed oil medium definitely had to be discarded because of its lack of permanence.

The painting techniques presented in this book are, to all intents and purposes, traditional. Needless to stress that the traditions relied upon come from the best sources. And as the "best" I consider methods that produced paintings of unsurpassed permanence and beauty. The oldest of these methods is the one employed by the Flemish masters beginning with the latter part of the fourteenth century.

vii

In the matter of procedures, I have never had anything to offer that could improve upon the time-honored methods, hence my strict adherence to the "gospel" preached by the masters. This, of course, does not imply that following sound technical processes necessarily leads to conformity with the classic school of painting. On the contrary, once the alphabet of painting, as it were, is mastered, one's vocabulary can be freely and successfully employed for the expression of most personal statements.

Frederic Taubes
New York

# CONTENTS

ix

# LIST OF PAINTINGS

Frederic Taubes
# Oil Painting
## for the Beginner

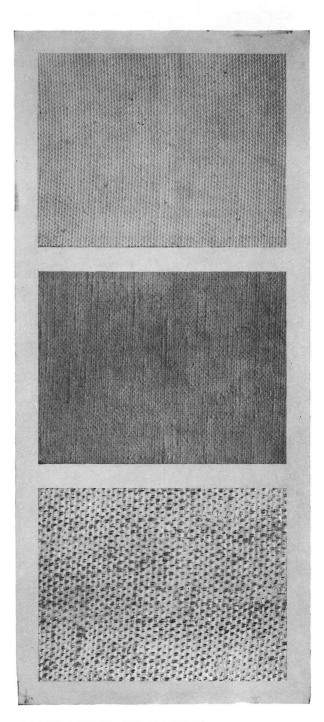

**A**
*COTTON
CANVAS
The grain is too mono-
tonous in appearance for
best results*

**B**
*LINEN CANVAS
The grain is less mechan-
ically even and hence
more pleasing*

**C**
*LINEN CANVAS
A coarse canvas often
needs special preparation
by the artist*

*SOME TYPES OF CANVAS*                    *Figure 1*

# CHAPTER I: SUPPORTS AND GROUNDS

Obviously the first thing which interests the beginner about to venture into the field of oil painting is the acquisition of the necessary equipment. There is a peculiar fascination among most art-minded people—beginners in particular—in all the paraphernalia of the craft. Because of this fascination, the novice is apt to acquire too many things too hastily.

But what, of all the multiplicity of items which the dealer displays, *is* one to select? In these first pages our primary purpose is to answer this question, for it is highly important for the novice to get the right start.

## THE CHOICE OF THE SUPPORT

Before undertaking our discussion of the various materials or surfaces on which paintings are made, let us examine the meaning of the two terms "support" and "ground." "Support," as the name implies, relates to the foundation or backing of the surface or coating on which the painting is done; the surface itself is called the "ground." The principal supports are linen or cotton fabrics affixed to stretchers, or to a composition board known as (untempered) Masonite which, under present conditions is considered the best material. In case of a panel, a gesso ground is used, but fabrics are primed with an oil ground only.

## COTTON CANVAS

Canvas is by far the most popular support. It is sold at almost every artists' materials store, either by the yard or roll. It comes

15

already prepared for use. Two general types are on the market: one of cotton and the other of linen. Some canvases are made of mixed materials or of jute. However, the cotton or linen canvas is preferable.

The quality of cotton canvas varies greatly, but it all has one common deficiency—the uninteresting, monotonous, machine-even appearance of its surface texture. (See A, Fig. 1.) When one paints thinly on such a canvas, the mechanical uniformity of the grain becomes the dominant characteristic of the painting's texture. Since this uninteresting texture of the painting is forever clearly discernible on such a canvas (unless an unusually heavy paint layer remedies this deficiency), it is obvious that even a painting executed by a good painter will suffer.

However, the character of the surface of cotton canvas, as supplied by the manufacturer, may be improved by the artist by an additional application of a ground, prior to painting. This is done in the following manner: A commercial white lead, as sold in cans, is spread in a thin fashion with a straight-blade palette knife (see Chapter V), on top of the original painting ground. Pressure should be applied to the knife when spreading the white lead, in order to push the paint into the grain of the fabric. The surplus of this white lead base should then be scraped completely from the canvas—it is important to have the final surface as even as possible. Should the white lead paint of the canned variety appear to be too heavy, it may be thinned to a somewhat looser consistency with copal resin varnish. (See Chapter IV for a discussion of varnishes.) A canvas prepared in this manner by the artist should be permitted to dry for about a week before painting.

## LINEN CANVAS

Linen canvas, which comes in many qualities, has, as a rule, a much more interesting grain than cotton canvas. The cheaper

grades of linen canvas are lighter in weight, their fabric is more loosely woven, and their thread is often irregular in thickness. Although the evenness of the more expensive canvas is especially praised by some, I hold that the irregular weave is more desirable because it improves the textural appearance of the canvas surface. (See B, Fig. 1.) As I have just pointed out, it is very annoying to paint on a mechanically perfect canvas grain.

Linen canvas differs also in the degree of roughness of the fiber.

To be sure, the choice of a suitable surface is a matter of personal preference, but certain considerations must be taken into account when choosing a canvas, because the characteristic of this surface will influence the working method of the painter, regardless of his personal preference. An over-smooth ground, without tooth, will not be suitable for "pastose" painting (work where the paint is thickly laid on). The paint tends to slide around on such a ground, and an "impasto," as such a heavy application is called, will not generally look too well on it. For thin painting, however, a smooth canvas ground is most appropriate. On the other hand, a very coarse canvas grain will require a considerable quantity of paint before the painting will take shape; thus the painter will first have to fight the roughness of the canvas; that is, he will have to fill the pores of the surface with paint. (See C, Fig. 1.) A thinly executed painting may simply disappear in the interstices of a coarse canvas grain. Often a coarse surface may be improved by sandpapering. One may apply also a new white lead ground to a canvas which appears to be too rough.

From all these considerations it appears logical that a canvas neither too coarse nor too smooth should be used for painting.

The priming on all the discussed canvases is prepared by the manufacturer with a white oil paint; therefore, it is known as oil priming. This oil ground is practically non-absorbent; hence, it is most suitable for oil painting. (An absorbent ground is known as a "gesso" ground. Gesso is prepared from glue size and white pig-

ments such as whiting, zinc white and titanium white, and it is used on panels only.

Lately, by the way, there appeared on the market a painting canvas made of glass fiber; it possesses superior properties in regard to tensile strength and resistance to moisture. However, as in the case of the cotton fabric, the texture of the glass fabric is much too uniform and monotonous.

## RIGID SUPPORTS

Besides the canvas support, we again point out that there are also rigid supports for painting, such as canvas-covered board, academy board, Masonite, or Presdwood panel. A commercial canvas-covered cardboard is so forbiddingly ugly that it offers a serious handicap in painting. Academy board, although an inferior material, is usable for sketching, though I would not recommend it for more serious work. Presdwood is a trade name for a hard variety of Masonite panel. This support is most durable and is often employed in oil painting. There also are wooden panels, mostly plywood material, which, however, offer too many inconveniences to be considered practical for painting. For example, they often crack and warp, especially when exposed to steam heat. A properly cradled and seasoned hard-wood panel made from oak or mahogany is certainly an excellent painting support, but the price is usually prohibitive. (A "cradle," incidentally, is a lattice-like frame used for reinforcing the back of a wood panel.)

I prefer the flexible canvas to all of these other supports because, due to its flexibility, it is more responsive to the striking of the brush or palette knife. I recommend that the student acquaint himself thoroughly with this before trying others.

# CHAPTER II: BRUSHES, THEIR PROPERTIES AND CARE

WE WISH TO STRESS brushes thus early, for far too little attention is generally given to them by professional painter and amateur alike. The brush really is to the painter what the bow is to the violinist; the serious violinist pays great attention and gives zealous care to this implement.

I have seldom failed to discover in the paint box of the art student an array of brushes which is entirely useless and which constitutes a serious impediment rather than a help in carrying out his task. One should keep in mind that the physical properties of the brush will imprint their characteristics on the canvas with telling results; that is, the appearance of the painting will reflect the nature of this tool.

Let us here divide brushes into two categories: (1) *bristle brushes*, (2) *flat and round sable brushes and blenders*. Bristle brushes produce rough paint configurations, whereas the sable brushes produce a smooth appearance of the paint surface. The most delicate blending can be obtained with the help of a blender.

## BRISTLE BRUSHES

The bristle brush is manufactured in two varieties, one having short and the other long bristles. (See Fig. 2.) Both of these brushes behave differently in use. The short bristles can pick up a larger load of paint from the palette because of the greater resilience of the bristles. But the short bristles do not have the elasticity of the longer ones; hence their stroke will be less fluid, and will leave a deeper mark on the paint surface.

Bristle brushes range in size up to No. 12, which, in most makes, is about 1 inch in width. There are larger brushes, but these seldom find use in easel painting. In Nos. 4 to 12, the short-bristle brush will be quite practical. Should a brush smaller

*Figure 2*

than No. 4 be needed, a sable brush will be more appropriate. Long-bristle brushes are practical in Nos. 5 to 10. (All the sizes here given are for flat brushes. There are also round bristle brushes on the market, but these are quite useless. Round brushes should be made of soft hair such as sable.)

## SABLE BRUSHES

These are both round and flat. (See Fig. 3.) The size of the round sable brush ranges up to No. 22, and the usable size, whatever its purpose (with the exception of miniature painting), begins with No. 3. For draftsman-like effects, for outlining, and for painting details, these round sable brushes are indispensable. They produce the fluid, unimpeded strokes and register the per-

*Figure 3*

sonal handwriting of the painter with great ease. The best quality of soft hair is red sable, and the longer the hair, the longer the lifetime of the brush. Hair that is too long, however, will lack the necessary resilience for the manipulation of oil paint. The wooden handles of these brushes should be long so as to fit with the other brushes held in one's hand.

Flat sable brushes vary in size up to No. 16, which is about ⅝ of an inch in width, and which will prove sufficient for easel paintings even of a large dimension. The smallest flat sable brush for practical purposes is about No. 6. Sable brushes of the water color type may also be obtained in sizes of 1 inch and more.

## BLENDERS

The blenders are manufactured from various types of soft hair. (See Fig. 4.) Such brushes will serve to effect delicate tonal transitions, since their hair is too soft to exert any marked pressure on the paint surface. One or two blenders in sizes of ½ inch to 1 inch will be adequate for all purposes. The shapes of blenders vary from flat to semiround and round, but the flatter ones are more suitable for blending.

All our paint brushes are made from hair which has not been trimmed. Cutting of the natural end of hair renders it unfit for use in painting. When buying a brush one should take into considera-

*Figure 4*

tion that it is always good economy to buy the more expensive one, since it will long outlast the cheap product.

Some European-made brushes have their hairs set in pitch, which softens when exposed to heat. When such a brush wears down, it is therefore possible to restore the length of the hair or bristle by heating the ferrule over the flame of a match and pulling the hair or bristle part way out of the ferrule to extend the length from ⅛ to ½ inch. The lifetime of such a brush will thus be considerably increased. (The pitch which clings to the hair may be washed out with benzol or any paint remover.) Unfortunately, American-made brushes are set in a cement which does not permit such an operation.

## VARNISHING BRUSHES

These are dealt with later—see Chapter XXIV.

## CARE OF BRUSHES

It is not only the quality of the brush and the working method of the painter which account for the life span of a brush, but it is to a large extent the care bestowed upon it by proper cleaning. Brushes should not be allowed to dry with the oil paint in them, but should be washed with soap and water after the paint has been squeezed out with newspaper. (In doing this squeezing, one should hold the brush at the ferrule in order not to loosen the ferrule from the handle.) To effect a complete removal of the paint, a prolonged lathering of the bristles with soap on the palm of one's hand is essential. Every trace of paint should be eliminated from the neck of the ferrule where the decay of a brush starts. A brush stained with a light color may appear to be clean after superficial washing, but to realize how long it takes to dissolve and rinse

away the oil paint completely, one should observe the time needed to remove all visible traces of paint from a brush stained with a dark color.

Brushes which have become sticky from half-dried varnish, or which have hardened due to oily or resinous residue, should be soaked first in a strong solvent such as crude benzene (also known as painter's thinner), or in benzol or a paint remover, after which they should be washed with soap and water. A resin-hardened brush may be softened easily by means of turpentine or any of the petrol solvents.

Before putting away the soft sable brushes, one should press them into the original shape; that is, the round brushes should dry with a point and the flat brushes should dry with all the hairs pressed well together, and not sticking out as from an old broom.

Bristle or sable brushes which have become misshapen (through careless storage in a paint box, for example), should be dipped into mucilage or a thin glue solution, after which they should be pressed into the proper shape and permitted to dry. In a week or more the adhesive may be washed out.

The best way to keep brushes is in a jar. Sable brushes which are to be stored for a long period should first be moth-proofed with naphthaline.

# CHAPTER III: THE CHOICE OF COLORS

LET ME HERE STATE for the record that, in spite of the glamour attached to foreign-made colors, American paints are, on the whole, more reliable, since all the important manufacturers of oil colors adhere to the standards approved by the U.S. Department of Commerce. Moreover, the content of a tube is clearly marked on the label, a procedure which is not followed by the foreign manufacturer. This assures the painter an unadulterated product.

Cheap grades of color with unspecified contents should be avoided, as most of them are not prepared from genuine pigments; they are deficient in many respects and often constitute an impediment in the progress of the work. A student should not necessarily acquire the most expensive colors, because even the finest colors will not be the deciding factor in the creation of "masterpieces." A medium-priced oil color produced by a reliable company will prove satisfactory so far as permanence and tinting strength are concerned.

Frequently the question is put to me whether it is advantageous to prepare one's own colors. In my opinion it is inadvisable for an amateur to go into this relatively intricate procedure. Only an experienced practitioner may expect satisfactory results in grinding the pigments himself. When improperly handled, even the best of raw materials will yield inadequate colors.

The palette—here the term is used to indicate one's assortment of paints—should be limited to a few colors, because it is a well-known principle that a multitude of colors will not be helpful in producing a colorful painting. However, I see no reason for one to exercise excessive frugality and restrict oneself—as is sometimes advocated—to five, six, or eight colors. I believe the following selection of colors to be essential:

24

## A SELECTED LIST

*White*

White lead (flake white)

*Blue*

Prussian blue
Ultramarine blue

*Green*

Viridian green

*Yellow*

Yellow ochre
Cadmium yellow light

*Red*

Venetian red
Cadmium red light
Alizarin crimson

*Brown*

Burnt sienna
Burnt umber

*Black*

Ivory black

To this selection I would like to add Naples yellow, cadmium orange, Indian red, and cerulean blue.

## PHYSICAL PROPERTIES OF COLORS

The reader will be aware of the fact that I have omitted here a discussion of the chemical properties of colors. So much is heard about color chemistry these days that this ominous word "chemistry" seems to be the very anathema to permanence in painting. It is true that in the past incompatibilities of chemical nature accounted largely for the decay of paintings. Today, due to the advance in color chemistry, such a danger is to all intents and purposes excluded. And so when a painting executed with present-day materials, some of which I list here, darkens, cracks, or discolors, this must be blamed on faulty technique and not on chemical incompatibility of paint.

### White Colors

The best of all white paints is the ancient, time-tested *white lead* (flake white, Cremnitz white). It possesses great opacity, dries well,

and is most suitable for pastose painting (work where the paint is thickly laid on). *Zinc white,* which, for some mysterious reason, is the most popular white color with our contemporary painters, is inferior to white lead in every respect but in whiteness; it also yellows less than the former. However, a good white lead will not yellow to any objectionable extent, and I, for my part, do not favor the cold glaring whiteness of zinc white. Better than pure zinc white is a combination of titanium dioxide, zinc white, and barium sulphate. Such a white is sold in tubes under various trade names. For people who are physically allergic to the lead color, or who are prejudiced against it, the titanium-zinc white-barium combination is recommended.

Students may just as well use the commercial white lead as sold in cans. It is considerably less expensive than the tube color, and about its only disadvantage is its tendency to yellow more than the tube color. To overcome this, one part of white lead may receive an equal part by volume of titanium dioxide. (This is obtainable in powder form and must first be mixed with linseed oil to a thick consistency. For mixing, use a palette knife.) Add the titanium dioxide to the white lead and mix thoroughly. In order to increase the brushability of this paint, a little of the painting medium should be added to it. The best medium for thinning paint to any desirable consistency is the copal painting medium (light or heavy), produced after my formulation by Permanent Pigments. Other copal painting media available in trade vary greatly in their qualities.

### Blue Colors

*Prussian blue* has for a long time been disdained for reasons based more on prejudice than on facts. This color is extremely powerful; that is, it possesses extraordinary tinting strength. It

dries exceptionally well and belongs to the more transparent colors; it is, however, not often used in a transparent fashion but mostly as an addition to other colors. *Ultramarine blue* is a transparent, moderately well-drying color. The commonly used variety of ultramarine has a violet cast. *Cerulean blue,* on the other hand, is opaque, dries exceptionally well, and possesses good tinting strength and hiding power. (It is doubtless clear that the term "tinting strength" relates to the capacity to impart color, while "hiding power" refers to the degree of opacity of a paint.) Being an expensive pigment, cerulean blue is often "cut" with "fillers" —i.e., mixed with inert material serving as an extender in the preparation of paint. The so-called "cerulean tint," as sold in tubes, is a mixture of white, viridian green, and ultramarine.

## Green Colors

The only unmixed green on our palette is *viridian green* (other greens can be omitted). It has little hiding power, moderate tinting strength, dries moderately well, and is very transparent. All other greens will be obtained from mixtures of other colors.

## Yellow Colors

*Yellow* or *light ochre* is known as an earth color. Its dull tone is most useful in painting. It is semi-opaque and dries moderately well. *Cadmium yellow* is an exceptionally brilliant color; its virtue lies in its great tinting strength. It is a poor drier and possesses little opacity. One should beware of imitations of this yellow. Imitations may appear on the outside to be equally brilliant, but in mixtures their tinting strength is inferior. The cadmium-barium colors are unobjectionable. *Cadmium orange* is an orange variety of cadmium yellow. *Naples yellow* is an opaque, pale color of excellent hiding

and drying power. One should try to obtain the genuine product, since Naples yellow in tubes is often nothing more than a white color mixed with some yellow tints.

## Red Colors

*Venetian* or *light red* is our old standby. Like ochre, it is an earth color. Its opacity and tinting strength are great; it dries moderately well. The uniformity of the hue of this color varies with different makes. Often a color designated as Venetian red has the tint of *Indian red.* To the eye, the only difference between these two colors appears to be the somewhat darker shade of Indian red. In itself, this does not seem to be a considerable difference. However, when mixing these colors with white, a marked difference becomes at once apparent. Venetian red will appear pink in such mixtures, and Indian red will be a dull violet. The latter has also a stronger tinting and hiding power. *Cadmium red* is a brilliant red of a beautiful glowing hue. Here, as with cadmium yellow, it is important to obtain the genuine color. *Alizarin crimson* is a very transparent color of excellent tinting strength. It dries very slowly.

## Brown Colors

*Burnt sienna* is a semi-transparent earth color of a glowing reddish hue. It dries moderately well and has good tinting strength. *Burnt umber* has a warmer and *raw umber* a colder brown hue. I believe burnt umber to be the more useful color; it eliminates largely the use of raw umber. (When I refer to "umber" in this book I mean specifically "burnt umber.") Umber is an earth color and is the best drier on the palette. Even a slight addition of umber will speed up the drying of any slow-drying paint. Its tint-

ing and hiding powers are also excellent. Umber, again, was for a long time in disrepute. I may add here that all the unfavorable rumors about this color are entirely unfounded.

## Black Colors

I should say, rather, "black color," because only *ivory black* is recommended here. It possesses a beautiful hue and excellent tinting power. But it is an especially poor drier.

*Observations:* When the slow-drying quality of a color proves a handicap, this may be overcome by adding to about two inches of the color paste, as squeezed from the tube, a drop of siccative. (One may well use an eye dropper for this purpose.) The coming chapter discusses siccative at greater length.

One may easily reproach the author about his choice of colors as listed on the preceding pages, on the ground that this choice is a personal one. This I do not deny. On the contrary, I affirm that the choice is the most sensible one, especially for the beginner. When the amateur has acquainted himself with these colors, however, there is no reason why he should not add some other colors to the standard list, providing that these are unobjectionable so far as their usefulness and permanence are concerned.

# CHAPTER IV: MEDIA, THINNERS, AND DRIERS

PAINTS as they come from the tube cannot very well be used without a thinner, referred to as a *painting medium*. There are various painting media; however, we shall limit ourselves to the best as described below.

## THE PAINTING MEDIUM

Linseed oil is used not only for grinding paints but it is also employed as a part of our painting medium. However, undiluted linseed oil has certain deficiencies because of inherent characteristics such as its lack of viscosity and its fatty constituents. To make it more appropriate for application in various techniques, linseed should be combined with a resin and thinned with turpentine. One such linseed oil-varnish preparation is known as Copal Painting Medium. It is compounded after my own formulation by Permanent Pigments of Cincinnati, Ohio, and is generally available in art supply stores. The linseed oil, which is part of the medium, is thermally processed, and as such it is known as stand oil. Stand oil is superior to all other drying oils with regard to non-yellowing and toughness. In combination with the copal resin (a hard resin found in the Congo), it is considered the most versatile and permanent of all resinous media. It is manufactured in three distinct consistencies: Copal Painting Medium Light, Heavy, and Copal Concentrate. The difference between the first two lies merely in viscosity. The lighter medium is less viscous, therefore more suitable for extra thin applications. However, the choice of one or the other is a matter of personal preference. Copal Concen-

30

trate should be added in small quantities to the paint as it comes from the tube to make it more glossy and viscous.

Copal resin in a painting medium is much superior to damar (see page 32), first in point of permanence and quick drying. Second, the addition of a varnish promotes a better adhesion of the paint and brings out the brilliance of the colors to best advantage.

## TURPENTINE

As used for our purposes, turpentine should be of the type known as "gum" turpentine. This specification indicates that the turpentine has been distilled from the sap of pine trees. The cheaper kind is the product of destructive distillation of pine wood. There is no need for the painter to bother about especially distilled— the so-called "double-distilled"—turpentine, because gum turpentine, which is produced by large concerns, is, when fresh, of such high quality that a re-distillation doesn't seem necessary.

It should be stressed emphatically that turpentine—a favorite paint thinner used by the uninformed—is not a painting medium. In fact, paint diluted by turpentine is not only difficult to handle, but also lacks stability. However, turpentine, when brushed onto a paint film, will help prevent the paint from "trickling." Paint "trickles" when it forms little droplets on a canvas instead of going on smoothly over an underlying layer of paint. The reason for the occurrence of trickling has never been sufficiently explained.

## PETROLEUM THINNERS

Two kinds of petroleum thinners, *mineral spirits* and *benzol*, will be useful to the painter. Mineral spirits is sold under such trade names as Varnolene, Sonoco Spirits, Texaco Spirits, etc. It has similar characteristics to turpentine and may be substituted

for it. Mineral spirits is, like the latter, especially adapted as a mild paint remover for paint films which have not hardened; it is also useful for cleaning brushes. In combination with benzol, it will have a far stronger solving action. For the purpose of a paint remover, the addition of benzol to mineral spirits may range from 10% to 50%, depending on the age and toughness of the paint film.

A commercial paint remover can be used to soften paint hardened brushes. The paint remover is not harmful to the bristles or sable hair; after using it, the brushes should be washed.

## VARNISHES

Varnishes are solutions of resin in volatile media such as turpentine or mineral spirits. (Resins are natural exudates from trees. Damar resin, or gum damar as it is known, is a solidified sap of pine trees which grow in Malaya and Indonesia.)

I have developed my own formulas for the three general types of varnish, and these are manufactured and sold by Permanent Pigments.

1. *Damar Solution, Heavy,* used as an addition to linseed oil and in preparation of tempera emulsions.
2. *Damar Picture Varnish* is used as a final picture varnish; that is, applied after a picture has dried well. Depending on the thickness of the paint film, it can take from three to twelve months for the paint to dry thoroughly.
3. *Retouching Varnish* differs from the two I have mentioned, inasmuch as it contains less damar resin, and is more volatile. The varnish can be used as soon as a painting is dry to the touch, a week or two after its completion. However, on a fresh paint layer the varnish does not last well; hence, revarnishing after several months will be necessary. Why should you use re-

touching varnish? First, to revamp a "sunk-in" color. A color loses its true value chiefly because the underlying paint film absorbs the oil. Therefore, varnishing becomes imperative because it re-establishes the original color at once. Varnishing also protects the paint surface from atmospheric dirt. However, retouching varnish is not as durable as the final damar picture varnish.

## SICCATIVES OR DRIERS

These are compounds which serve to speed up the drying process of oil paints. The best of these is known as cobalt drier. It is a thin, ink-like liquid which should be used sparingly, since its excessive use will impair the permanence of an oil painting. Siccative should be added to the paint medium and to the oil colors as well. An addition of one drop of a drier to 2 teaspoonfuls of the painting medium, and one drop of it to about 2 inches of the color paste as squeezed from the tube, will make the slowest drying colors dry out in less than twelve hours.

When painting under adverse climatic conditions—that is, in an atmosphere saturated with moisture—the use of a siccative may prove essential. But though cobalt siccative is a very common and inexpensive medium, it is generally unobtainable in most of the paint stores. Usually inferior or deleterious materials are offered to the painter, for reasons which I have never fathomed. When buying a siccative, one should accept no other medium than the cobalt drier.

# CHAPTER V: OTHER TOOLS AND UTENSILS

IN ADDITION to the supports on which the painting is executed, the brushes and paints with which it is done, and the media, thinners, and varnishes just described, but few things are needed. The following are the most essential.

## EASEL AND PALETTE

The easel should be sturdily built so as not to shake and sway when one uses some force in the exercise of the brush or the palette knife on the canvas. It should also be adjustable to a convenient height.

The palette should be made of wood, and should have the natural color of wood. When I say "should," I am stating my personal preference. Some painters use a palette made of glass, or of plastic

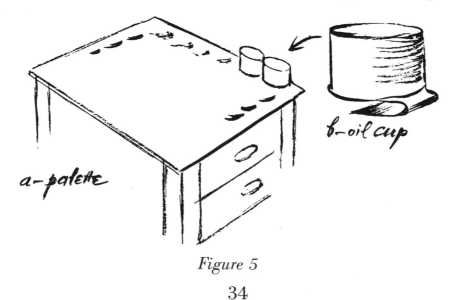

*Figure 5*

34

—and they fare quite well. I, however, prefer the plastic on automobiles and the glass in windows; I feel that wood is the more noble material for a palette, and more pleasant to behold.

The palette should be placed at one's left on a stool or a table at the height of his hip. Such an arrangement is much more convenient than holding the palette on one's arm, because it affords the painter greater freedom of movement. I recommend that the top of a small table be used as a palette. (See Fig. 5,a.) Two small oil cups (Fig. 5,b), to contain the painting medium and varnish, should be placed on the right upper corner of the palette. This table should have a cover to protect the paints from dirt.

## PALETTE KNIFE

The palette knife has a double purpose. It is used both for mixing and applying paint. It should be straight. (Fig. 6,b.) The trowel-shaped knife is not very suitable for painting. (Fig. 6,a.) For painting small areas, the blade of a knife should be 3 inches long, but for painting larger surfaces, a 4 inch blade is more convenient. The proper degree of elasticity of a blade is also very important. A stiff blade will do well in underpainting, but for final execution of a painting we shall need an elastic one.

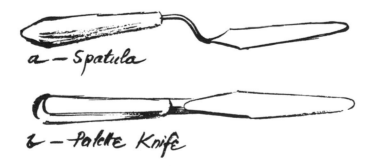

*Figure 6*

## PUTTY KNIFE

A putty knife (Fig. 7,a) will be useful for scraping dry paint from the palette. One should refrain from employing a painting knife for this purpose, because even the slightest injury to the blade will make it useless as a painting instrument.

## SCRAPER

Another useful instrument is a scraper. (See Fig. 7,b.) It is convenient for scraping off a dried impasto and likewise for scraping into a wet paint when one wishes to reveal the under-

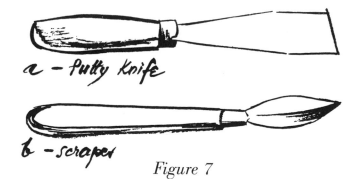

a – Putty Knife

b – scraper

*Figure 7*

painting. Sandpaper may also be utilized to scrape an old paint layer. One should choose a finer or coarser grade of the abrasive, depending on the thickness of the paint layer.

## PAINT BOX

For outdoor sketching, an oil painting outfit such as all dealers carry, consisting of a box providing spaces for palette, bottles of media, cups, brushes, tubes of paint, palette knife, etc., can prove a real convenience. Even in the studio some storage provision must be made for one's materials.

# CHAPTER VI: HOW TO MIX COLORS

ONCE ONE'S MATERIALS have been assembled, one is ready for the task of learning to mix colors. In this connection, a few basic principles should be observed.

Before discussing these principles, however, it seems advisable to pause a moment to clarify, in the following pages, my use of certain color terms which have often been employed so loosely that their meaning has become ambiguous.

## COLOR TERMS

The word "hue" relates to the name of a color. For example, an apple is red; red is the hue of the apple. Similarly, if we were to say "that barn is red," we would be referring to its hue.

The word "value" relates to the degree of lightness or darkness in a color. A light color is said to be light in value; a dark color, dark in value.

The word "tone" has several meanings, but as a noun it usually means much the same as value. Any color, light or dark, bright or dull, forms a tone on the canvas, regardless of its hue.

The terms "tint" and "shade" are closely related to "value" and "tone." The noun "tint" normally refers to a color which, in respect to value only, resembles white more than it does black. The noun "shade," on the contrary, refers to a color which, in respect to value only, resembles black more than it does white. In other words, a tint is relatively light, and a shade relatively dark. This being true, it is not the best practice (though quite a common one) to say "a tint of dark brown," or "a shade of pink." One would, instead, refer to "a shade (or tone) of dark brown,"

37

and "a tint (or tone) of pink." As another example, one would be wise to avoid the common phrase "a pastel shade," for this is, from the colorist's standpoint, a contradictory misnomer unless it is used in reference to a dark tone of pastel, which is far from its commonly accepted meaning. The correct expression for a soft, light color would be "a pastel tint (or tone)."

Colors are often referred to as "warm" or "cool." These terms apparently mean the same to all artists, the colors at the red end of the spectrum being "warm" or "hot," and those at the blue end "cool" or "cold." The warm colors, in other words, are the reds, oranges, and yellows—the colors of fire and blood. The cool colors are the blues—the colors of ice and water. The greens lie between, most yellow-greens properly being described as warm, and most blue-greens as cool. Violet is usually warm, because of its red content, but if it is definitely a blue-violet, "cool" might better describe it.

## PRINCIPLES OF COLOR COMBINATION

Returning to our opening thought, the student should be conscious of the principles governing color combinations. (For the expert, there is a great latitude in these principles, which, at times, may even be reversed.)

First, one should always endeavor to obtain a desired color effect by employing as few colors as possible. Besides white and black, two, or at most three, colors should suffice to produce a proper nuance. A combination of four colors (besides white and black) will be quite exceptional. And when a painter dips his brush at random all over the palette, this is a clear indication that he is groping in darkness and confused in his intentions. Moreover, it would be practically impossible for him to remember which colors went into the making of a certain effect if many of them were used together. A color combination, in short, should

not be the result of an accident, but it should be so planned that it can be re-enacted whenever the need arises.

An important consideration is the fact that through a thorough compounding of different colors the brilliance of these colors decreases. The more regularly the particles of different pigments are interspersed in oil, the duller the combination appears to our eye. House painters' colors represent such radically compounded pigments. On the other hand, a brief mixing of different colors will preserve their brilliance and create an iridescent effect. This is demonstrated on Color Plate 2, page 52; the method used is described on the graph opposite, and again on page 57.

White cuts the intensity of any other color or color combination, reducing all colors to pastel tints. Black not only reduces the intensity of other colors and darkens their value, but it also changes their character. Black, when added to any color combination containing white, will gray or neutralize it somewhat.

Generally, colors of approximately the same tinting strength will produce the most effective combinations. A mixture of a powerful and a weak color will be dubious because the powerful color may annihilate the weak one. Colors which are recommended here are all compatible one with another so far as chemistry is concerned. But one will hardly be tempted to mix a powerful color such as Indian red with the relatively weak ultramarine blue or viridian green; however, when a powerful color is well-tempered with white, even a weak tint may be mixed with it.

Some pairs of colors are more or less useless for intermixtures. Such colors are ultramarine blue and Prussian blue, ultramarine blue and cerulean blue, Indian red and burnt sienna, umber and alizarin crimson, etc. (See Color Chart on page 54.) So, as we see, some colors should not be mixed because of the variation in degree of their tinting strength, and some because they do not yield useful or agreeable color combinations.

In the following I shall describe how to mix various tones:

## Gray Tones

Black and white, the most obvious candidates for producing gray, are by no means the most practical ones, because only one "family" of cold grays is obtainable from such a combination. An addition of umber will introduce a warm element and thus increase the tonal range of these grays; also umber with white alone will yield a brownish, dull gray of no coloristic interest. If, however, we combine umber, Prussian blue, and white, the range of gray colors will be immeasurably richer. Ultramarine blue may also be used instead of Prussian blue. It is quite easy to change the tonal values of such a combination; by increasing the blue color, cold silvery hues will result, and by adding more umber, cold grays will change to warm grays. Without the admixture of white, umber and Prussian blue or umber and ultramarine may substitute for black.

The use of Prussian blue, umber, and white is also recommended because it combines three colors which dry exceptionally well, and this is very desirable, especially in underpainting.

Other combinations of gray tones may be produced from black, yellow ochre, and white—or black, Naples yellow, and white. Still another combination of grays may be derived from mixtures of green and red, since these complementary colors neutralize each other (white must always be added). A particularly beautiful gray will be derived from Venetian red, viridian green, and white. Also greens which are composed of cadmium yellow, and any one of our blue colors, may be used in combination with Venetian red and white, for gray tints.

## Pink Tones

Pink color is obtained from a mixture of white and red. The red may be either Venetian red or burnt sienna. Cadmium red and

white yield a sweet, unpleasant pink, and Indian red and white mixtures have a violet hue. When yellow ochre is added to either of these mixtures, the pink color becomes warmer, more lively and pleasant to the eye. Even an ugly violet-pink may be greatly improved through the addition of yellow ochre. Black, on the other hand, will gray down and dull all the pink tints. Naples yellow in combination with burnt sienna, or Venetian red and white will also produce interesting pink tones.

### Violet Tones

Violet colors are mixtures of red and blue. (Prussian blue, however, is an exception, because it tends to produce green or gray tones in mixture with warm colors.) Strong violet hues may be obtained from mixtures of Venetian red and ultramarine blue, or cadmium red and ultramarine blue, with or without white. Alizarin crimson and white will produce a peculiar strong violet. For various tones of violet, alizarin crimson may also be mixed with Venetian red, or cadmium red, and white.

### Brown Tones

Brown may be obtained from mixtures of black, yellow ochre, and burnt sienna. The hue of umber may be approximated with these colors. Such a brown color will dry slowly in contrast to umber, which is a very fast drier. Burnt umber, which is in itself a brown color, will produce various hues of brown in mixture with yellow ochre, burnt sienna, or both. An addition of white dulls such browns.

### Green Tones

Any combination of blue and yellow color, or black and yellow color, will result in a green. Cadmium yellows will produce strong

and vivid greens when mixed with blues; but yellow ochre or Naples yellow will yield dull greens. So, for strong greens, we shall use cadmium yellow mixed with Prussian blue, ultramarine blue, cerulean blue, or viridian green; and for dull greens, Naples yellow, or yellow ochre, with one of the above-mentioned blues or viridian green. An addition of white to any of these mixtures will dull the green tints. Also, black will lower the intensity of the greens. But, black in combination with cadmium yellow alone will produce a strong green. Black with yellow ochre or Naples yellow will yield beautiful dull greens. Darkest greens may be obtained from burnt sienna and Prussian blue. Likewise, black with a slight addition of cadmium yellow or cadmium orange will produce very dark greens. And lastly, brown colors, such as umber, burnt sienna, and yellow ochre will appear greenish when tempered with the cadmium yellows.

### Red Tones

Red tones result only from mixtures of red colors, for red is one of the so-called "basic" or "primary" colors. Venetian red, Indian red, and cadmium red (the last one being less opaque than the former) may be darkened with umber (or black, which will make such colors more dull). To make a red lighter or brighter, cadmium yellow or yellow ochre may be used. However, this brightening of the red color with cadmium yellow can be effected only to a moderate degree. Too much of the cadmium yellow will turn the red color into an orange, and too much yellow ochre will deprive it of its characteristic hue. The dull hue of the Indian red may be successfully influenced through an addition of cadmium orange.

### *Yellow and Blue Tones*

Yellow, like red, is primary or basic and cannot be mixed from other colors, though it can of course be modified in innumerable ways through admixture, much as red can be.

Similarly, blue is primary and cannot be created by mixing other hues, though it can be modified with ease.

\*       \*       \*

To some amateurs, methodical discussion of coloristic problems such as those presented on the accompanying pages may seem like a dull beginning with which one would rather not be encumbered. However, one should be aware of the fact that in art—as in most other disciplines—knowledge comes first, and inspiration enters a while later, optimistically speaking. Hence, it cannot be over-emphasized that the student should endeavor to acquire a thorough knowledge of all the coloristic possibilities his colors offer, so that he can depend on experience rather than on guesswork.

# CHAPTER VII: PRELIMINARY PRACTICE

BEFORE HE ATTEMPTS to paint any pictures, the beginner should acquaint himself, through exercises, with all the color combinations given on this and the next page. Such exercises should be systematically carried out on canvas, academy board, or sized paper, the last-named being the most economical. (For sizing the paper, one may use 1 ounce of commercial gelatin or such as is used in cooking, dissolved in a quart of hot water. The paper should first be glued to a picture stretcher—see Chapter IX—and the size applied to it with a house painters' brush.)

I shall list here all the discussed combinations of colors to be mixed by the student as an exercise.

## Gray Tones

Prussian blue, umber, white
Ultramarine blue, umber, white
Cerulean blue, umber, white
Black and white
Black, yellow ochre, white
Black, umber, white

Umber and white
Black, Naples yellow, white
Venetian red, viridian green, white
Venetian red, Prussian blue, white
Venetian red, green (any combination of cadmium yellow and blue), white

## Pink Tones

Venetian red, white
Venetian red, yellow ochre, white
Burnt sienna, white
Burnt sienna, yellow ochre, white
Cadmium red, white
Indian red, white

Indian red, yellow ochre, white
Naples yellow, Venetian red (and white)
Naples yellow, Indian red (and white)
Naples yellow, cadmium red (and white)
Naples yellow, burnt sienna (and white)

## Violet Tones

Venetian red, ultramarine blue, white
Cadmium red, ultramarine blue, white
Alizarin crimson, white
Alizarin crimson, Venetian red, white

Alizarin crimson, cadmium red, white
Alizarin crimson, ultramarine blue, white
Alizarin crimson, Prussian blue, white

## Brown Tones

Black, yellow ochre, burnt sienna
Black, burnt sienna (and white)
Black, umber (and white)
Umber, white

Umber, Naples yellow
Umber, yellow ochre
Burnt sienna, yellow ochre

## Green Tones

Prussian blue, cadmium yellow
Prussian blue, cadmium orange
Prussian blue, yellow ochre
Prussian blue, Naples yellow
Prussian blue, burnt sienna
*Besides Prussian blue, ultramarine blue or cerulean blue may be used for greens in combination with the above list of colors.*
Viridian green, yellow ochre
Viridian green, Naples yellow
Viridian green, umber
Viridian green, cadmium yellow
Viridian green, cadmium orange
Viridian green, ultramarine, cadmium yellow

Viridian green, ultramarine, yellow ochre
Viridian green, ultramarine, Naples yellow
Viridian green, Prussian blue, cadmium yellow
Viridian green, Prussian blue, yellow ochre
Viridian green, Prussian blue, Naples yellow
Black, cadmium yellow
Black, cadmium orange
Black, yellow ochre
Black, Naples yellow
Cadmium yellow, umber

## Red Tones

Venetian red, yellow ochre
Venetian red, cadmium yellow
Venetian red, cadmium orange
Venetian red, cadmium red
Venetian red, umber
Venetian red, black
Indian red, yellow ochre
Indian red, cadmium yellow

Indian red, cadmium orange
Indian red, cadmium red
Indian red, umber
Indian red, black
Cadmium red, yellow ochre
Cadmium red, umber
Cadmium red, black

### Yellow Tones

Cadmium yellow, yellow ochre (and white)    Yellow ochre, white
Cadmium yellow, white    Naples yellow, white
Cadmium yellow, Naples yellow (and white)    Naples yellow, yellow ochre (and white)

### Blue Tones

Ultramarine, white    Cerulean blue, white
Prussian blue, white

The exercises suggested in this chapter serve a double purpose. First, through the handling of the paint per se—detached from representational intentions—a more intimate acquaintanceship with the colors will develop and a greater understanding of their range will be gained. Secondly, if one prepares the charts in a systematic fashion, these charts may later serve as "samples," so to speak, from which various color suggestions may be obtained. For it is not likely that even an advanced student may retain in his memory a large range of color dispositions.

# CHAPTER VIII: OPAQUE AND TRANSPARENT COLORS

At the start, the beginner will perhaps not be greatly concerned with the use of a transparent color. However, it is a good plan for him to acquaint himself early with all the characteristics of colors in order to realize the possibilities to which any given color may lend itself.

When we examine our oil paints, it is quite important to differentiate between transparent and opaque colors. The degree of opacity or transparency of our colors varies greatly. Of course, even an opaque paint will become to some extent transparent when used in a thin fashion, and it may also become very transparent when it is strongly diluted with painting medium. A transparent color, on the other hand, cannot be used in an opaque fashion unless it is mixed with an opaque paint. In fact, a transparent color when used with impasto will lose its true color hue. Ultramarine, which is a transparent blue, will appear rather black when used in a thick layer. Also alizarin crimson, a highly transparent color of a glowing red hue, will be blackish when applied with impasto. Our next transparent color, viridian green, will likewise lose its intrinsic beauty when thickly painted on. Another transparent color is burnt sienna; it has a fiery red hue when applied thinly, but in thick layers it appears to be brown.

The following colors may be looked upon as semi-transparent: cadmium yellow and cadmium red, yellow ochre and Prussian blue (the latter is rather transparent, but since it possesses an inordinately strong tinting power, it appears almost as opaque). The remaining colors, white lead, cerulean blue, Naples yellow, umber, Venetian red, and ivory black, have various degrees of opacity.

An application of a transparent color will reveal the color of the underpainting, or of the white painting ground beneath. A color which possesses this degree of transparency is referred to as a "glazing" color, and the effect achieved with it is known as a "glaze." In other words, glazes are thin, transparent films of a darker color executed on a lighter underpainting. Since the transparent paint layers reveal the underlying ground, it stands to reason that the color of the ground will influence the hue of the superimposed glaze. Therefore, particular attention must be given to the underpainting when the use of a glazing color is planned.

I have introduced on Color Plate 1 (page 50) a few colors glazed on various underpaintings. (The original color combinations were generally too subtle to permit reproduction in their exact hues.) The student should explore as many such glazing possibilities as may be achieved. A number of these are suggested on Chart 1, page 49. This exercise may be executed on a sized paper or on a canvas. The underpainting should be applied to the canvas first, and should dry thoroughly before the glaze is executed. Immediately before applying the glaze, the underpainting should be slightly moistened with the painting medium. Rubbing some of the medium on the underpainting with one's finger will leave the surface just moist enough to permit easy manipulation of the brush. Even if used excessively, the copal painting medium will not have the tendency to slide down a vertically placed canvas.

As already mentioned, glazing applications are executed with darker colors on a light ground. So, if we consider the use of a lighter color—yellow ochre or Naples yellow, for example—in a transparent fashion, only white ground would be suitable for it. But such a glaze would hardly be attractive because these colors, due to their characteristics, do not lend themselves well enough to glazing. Cadmium yellow, a light and brilliant color, is, on the other hand, well-adapted to glazing because of its clear hue and strong tinting power.

49

| GLAZE | | | | | | | |
|---|---|---|---|---|---|---|---|
| *Ground:* White | Burnt sienna | Viridian green | Alizarin crimson | Ultramarine blue | Prussian blue | Cadmium yellow | Cadmium red | Umber |
| *Ground:* Cadmium yellow | Burnt sienna | Viridian green | Alizarin crimson | Ultramarine blue | Prussian blue | Cadmium red | Umber | Black |
| *Ground:* Naples yellow | Burnt sienna | Viridian green | Alizarin crimson | Ultramarine blue | Prussian blue | Cadmium red | Umber | Black |
| *Ground:* Light gray | Burnt sienna | Alizarin crimson | Cadmium yellow | Cadmium red | Ultramarine blue | Prussian blue | Umber | Black |
| *Ground:* Pink | Burnt sienna | Viridian green | Alizarin crimson | Ultramarine blue | Prussian blue | Cadmium red | Umber | Black |
| *Ground:* Cadmium red | Burnt sienna | Alizarin crimson | Viridian green | Prussian blue | Umber | Black | | |

| SCUMBLE | | | | | | |
|---|---|---|---|---|---|---|
| *Ground:* Dark brown or dark red, etc. | White | Yellow ochre | Naples yellow | Cadmium yellow | Cadmium red | Pink | Gray |

On the exercises executed by the student, the individual fields should be about 3″ square in order to demonstrate clearly the glazing effects

*CHART 1—SEE COLOR PLATE 1 (Next Page)*

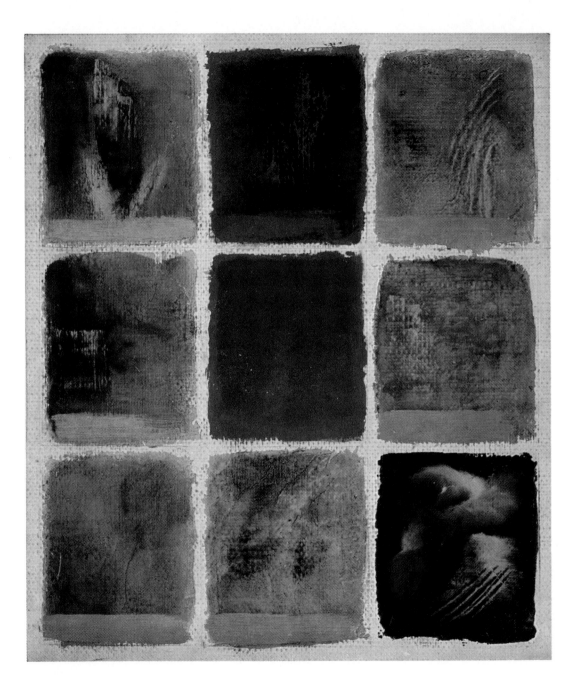

COLOR PLATE 1—GLAZING AND SCUMBLING

|  |  |  |
|---|---|---|
| *Underpainting:*<br>Cadmium yellow<br><br>*Glaze:*<br>Alizarin crimson | *Underpainting:*<br>Cadmium red<br><br>*Glaze:*<br>Viridian green | *Underpainting:*<br>Pink<br><br>*Glaze:*<br>Ultramarine blue |
| *Underpainting:*<br>Cadmium yellow<br><br>*Glaze:*<br>Burnt sienna | *Underpainting:*<br>Cadmium red<br><br>*Glaze:*<br>Alizarin crimson | *Underpainting:*<br>Pink<br><br>*Glaze:*<br>Viridian green |
| *Underpainting:*<br>Yellow<br>(ochre and white)<br><br>*Glaze:*<br>Umber | *Underpainting:*<br>Yellow<br>(ochre and white)<br><br>*Glaze:*<br>Prussian blue | *Underpainting:*<br>Dark brown<br>(burnt sienna<br>and black)<br><br>*Scumble:*<br>Naples yellow |

*GRAPH FOR COLOR PLATE 1 (Opposite Page)*

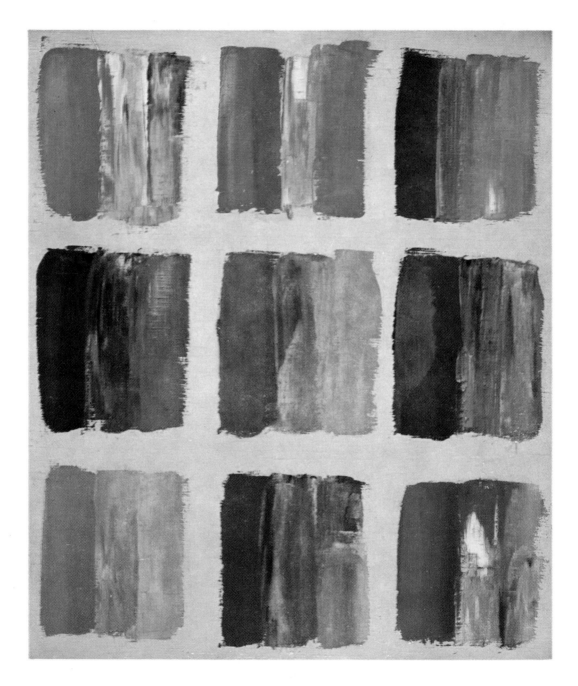

COLOR PLATE 2—COLOR COMBINATIONS

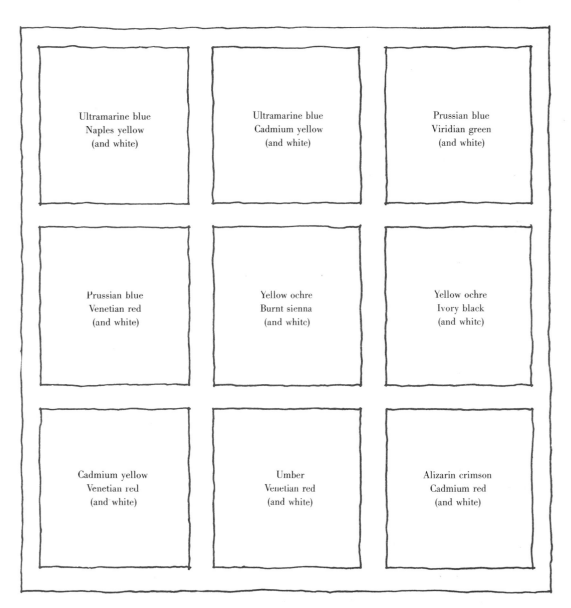

| | | |
|---|---|---|
| Ultramarine blue<br>Naples yellow<br>(and white) | Ultramarine blue<br>Cadmium yellow<br>(and white) | Prussian blue<br>Viridian green<br>(and white) |
| Prussian blue<br>Venetian red<br>(and white) | Yellow ochre<br>Burnt sienna<br>(and white) | Yellow ochre<br>Ivory black<br>(and white) |
| Cadmium yellow<br>Venetian red<br>(and white) | Umber<br>Venetian red<br>(and white) | Alizarin crimson<br>Cadmium red<br>(and white) |

Areas at the left of each of the six specimens on the Color Plate are mixtures of pure color, well compounded, without admixture of white. The colors adjoining these areas were applied with white directly to the canvas with a palette knife. In the latter, intimate intermixtures were not attempted.

*GRAPH FOR COLOR PLATE 2 (Opposite Page)*

| | | | | |
|---|---|---|---|---|
| Ultramarine blue Viridian green (and white) | Ultramarine blue Naples yellow (and white) | Ultramarine blue Yellow ochre (and white) | Ultramarine blue Cadmium yellow (and white) | Ultramarine blue Cadmium orange (and white) |
| Ultramarine blue Cadmium red (and white) | Ultramarine blue Burnt sienna (and white) | Ultramarine blue Venetian red (and white) | Ultramarine blue Umber (and white) | Ultramarine blue Alizarin crimson (and white) |
| Ultramarine blue Black (and white) | Viridian green Prussian blue (and white) | Viridian green Cerulean blue (and white) | Viridian green Naples yellow (and white) | Viridian green Yellow ochre (and white) |
| Viridian green Cadmium yellow (and white) | Viridian green Cadmium orange (and white) | Viridian green Cadmium red (and white) | Viridian green Burnt sienna (and white) | Viridian green Venetian red (and white) |
| Viridian green umber (and white) | Prussian blue Naples yellow (and white) | Prussian blue Yellow ochre (and white) | Prussian blue Cadmium yellow (and white) | Prussian blue Cadmium orange (and white) |
| Prussian blue Cadmium red (and white) | Prussian blue Burnt sienna (and white) | Prussian blue Venetian red (and white) | Prussian blue Indian red (and white) | Prussian blue Umber (and white) |
| Prussian blue Alizarin crimson (and white) | Prussian blue black (and white) | Cerulean blue Naples yellow (and white) | Cerulean blue Yellow ochre (and white) | Cerulean blue Cadmium yellow (and white) |
| Cerulean blue Cadmium orange (and white) | Cerulean blue Cadmium red (and white) | Cerulean blue Venetian red (and white) | Cerulean blue Umber (and white) | Cerulean blue Burnt sienna (and white) |
| Cerulean blue Black (and white) | Naples yellow Yellow ochre (and white) | Naples yellow Cadmium yellow (and white) | Naples yellow Cadmium red (and white) | Naples yellow Burnt sienna (and white) |

CHART 2 (See Color Plate 2)

| | | | | |
|---|---|---|---|---|
| Naples yellow<br>Venetian<br>red<br><br>(and white) | Naples yellow<br>Indian<br>red<br><br>(and white) | Naples yellow<br>Umber<br><br><br>(and white) | Naples yellow<br>Alizarin<br>crimson<br><br>(and white) | Naples yellow<br>Black<br><br><br>(and white) |
| Yellow ochre<br>Cadmium<br>yellow<br>(and white) | Yellow ochre<br>Cadmium<br>orange<br>(and white) | Yellow ochre<br>Cadmium<br>red<br>(and white) | Yellow ochre<br>Burnt<br>sienna<br>(and white) | Yellow ochre<br>Venetian<br>red<br>(and white) |
| Yellow ochre<br>Indian<br>red<br>(and white) | Yellow ochre<br>Umber<br><br>(and white) | Yellow ochre<br>Alizarin<br>crimson<br>(and white) | Yellow ochre<br>Black<br><br>(and white) | Cadmium yellow<br>Cadmium<br>red<br>(and white) |
| Cadmium yellow<br>Burnt<br>sienna<br>(and white) | Cadmium yellow<br>Venetian<br>red<br>(and white) | Cadmium yellow<br>Indian<br>red<br>(and white) | Cadmium yellow<br>Umber<br><br>(and white) | Cadmium yellow<br>Alizarin<br>crimson<br>(and white) |
| Cadmium yellow<br>Black<br><br>(and white) | Cadmium orange<br>Cadmium<br>red<br>(and white) | Cadmium orange<br>Burnt<br>sienna<br>(and white) | Cadmium orange<br>Venetian<br>red<br>(and white) | Cadmium orange<br>Indian<br>red<br>(and white) |
| Cadmium orange<br>Umber<br><br>(and white) | Cadmium orange<br>Alizarin<br>crimson<br>(and white) | Cadmium orange<br>Black<br><br>(and white) | Cadmium red<br>Burnt<br>sienna<br>(and white) | Cadmium red<br>Indian<br>red<br>(and white) |
| Cadmium red<br>Umber<br><br>(and white) | Cadmium red<br>Alizarin<br>crimson<br>(and white) | Cadmium red<br>Black<br><br>(and white) | Burnt sienna<br>Venetian<br>red<br>(and white) | Burnt sienna<br>Umber<br><br>(and white) |
| Burnt sienna<br>Alizarin<br>crimson<br>(and white) | Burnt sienna<br>Black<br><br>(and white) | Venetian red<br>Umber<br><br>(and white) | Venetian red<br>Alizarin<br>crimson<br>(and white) | Venetian red<br>Black<br><br>(and white) |
| Indian red<br>Umber<br><br>(and white) | Indian red<br>Black<br><br>(and white) | Umber<br>Alizarin<br>crimson<br>(and white) | Umber<br>Black<br><br>(and white) | Alizarin<br>crimson<br>Black<br>(and white) |

*CHART 2* (*Continued*)

When we apply a light color in a transparent or semi-transparent fashion on top of a darker underpainting, the resulting effect is known as a "scumble." (The word "scumble" is used by some artists with other meanings, but I hold that this present definition is the preferable one.) An example of scumbling is demonstrated in the lower right hand corner of Color Plate 1; see the graph, on the following page (51). The student should explore, for exercise, many scumbling possibilities. A few of them I suggest on Chart 1 (page 49).

On Color Plate 2 (page 52), a few demonstrations of opaque color applications are registered; see also the graph opposite this plate. On each square, two colors were mixed with each other. The colors, without white, were first well mixed with a palette knife. Next, white was added, and the colors were taken up with a palette knife and applied to the canvas without having been previously intermixed. As we see here demonstrated, the thoroughly compounded colors are dull as compared to the slightly intermixed colors.

All of the colors listed in our palette should be combined by the student as an exercise, as demonstrated on Color Plate 2 and Chart 2 (pages 54 and 55). Such an exercise should be carried out on sized paper or canvas. The color charts should be well studied by the student in order to acquaint himself with various possible color effects.

*Addenda:* In conclusion, it must be understood that glazing and scumbling can be done best with the copal painting medium, especially if paint has been previously conditioned by a substance called copal concentrate. Mix as much of the thick, viscous substance as a tip of a palette knife will hold, with about one inch of paint as it comes off the tube. Paint thus conditioned will become more lustrous, and more effectively manipulated. Thinning paint to any desirable degree with the medium can then proceed. The formula for this paint conditioning was given by Theophilus in the famous manuscript which dates from the fourteenth century.

# CHAPTER IX: STRETCHING THE CANVAS

Before starting our first serious painting—an attempt at a portrait—there are a number of practical matters which deserve attention. It is my purpose in this chapter and those immediately following to deal in turn with each of these problems.

The wooden stretchers to which the canvas is usually fastened before painting is commenced, are made up of patented strips which are purchased with their corners already mortised and tenoned, ready for quick assembly by the artist. It is a matter of but moments for him to assemble four of these strips to form a rectangular frame of any desired dimension.

When you have such a frame at hand, cut the canvas to a size 1 inch larger all around than the stretcher. (A canvas to be mounted on a 10 x 12 inch stretcher, for example, should measure 12 x 14 inches.)

Next, check with a carpenter's square whether the stretcher strips are correctly aligned. (See Fig. 8,a.) Stretcher joints which are loose should be submerged in water for a few minutes. This procedure will swell the wood and so immobilize the joints for some time.

Now place the canvas on the stretchers; its face should be turned from you. Fasten the canvas on the middle of a stretcher strip with an upholstery tack ⅜ inch long. (1, Fig. 8,b.) Pull the canvas in direction 2 and place the second tack near the end of a stretcher strip. Next pull the canvas in direction 3 and place the third tack near the opposite end of the stretcher strip. Fasten the canvas with the remaining tacks placed about 2 inches apart, as demonstrated by Fig. 8,c. (Each tack is marked on this sketch with an "x".)

Repeat the same procedure on the opposite stretcher strip and then fasten the canvas in like manner on the two remaining strips. Fold the canvas at the corners as illustrated by Fig. 8,d. To stretch the canvas taut, "keying off" the stretchers may be necessary. The keys (small wooden wedges which come with the stretchers) should be placed in the grooves with which each stretcher strip is provided, and hammered in carefully. To arrest these keys in place, drive a nail in front of each. (See Fig. 8,e.) When the work is completed, the canvas should be smooth and taut, but it should not be overstrained.

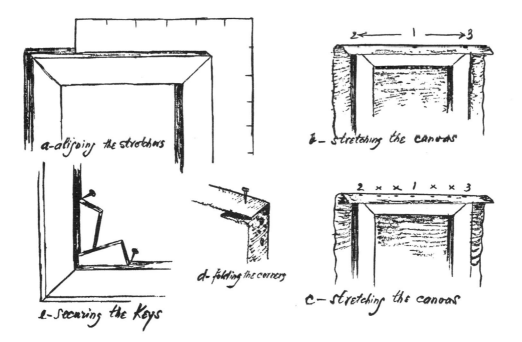

a-aligning the stretchers

b-stretching the canvas

d-folding the corners

c-stretching the canvas

e-securing the keys

*Figure 8*

# CHAPTER X: TRANSFERRING THE DRAWING

IT IS POOR STRATEGY to draw directly on the canvas. Generally, before the drawing takes a desired shape, the first sketch will require numerous revisions. I do not mean to say that only the beginner will have to struggle with the development of a good design. Even the most experienced painter will frequently resort to many preliminary sketches and will effect many changes and corrections before the plan of the painting emerges in its final shape. Should all these changes be carried out on the canvas, it would often become badly marked and battered before a brush ever touches it. Even when a design has been properly developed on the canvas, one may later realize that it needs to be moved in one or the other direction in order to achieve a proper balance on the assigned space. Should such a necessity arise, even the most perfect drawing would be useless, since it would have to be deleted and redrawn in a different position.

To avoid complications of this kind, a design should first be developed on thin tracing paper and then transferred to the canvas. The tracing paper (a thin, semi-transparent paper) can conveniently be cut to about the size of the stretched canvas. It can then be laid over the canvas and held in place with a few thumbtacks pushed into the stretcher strips. Thus the stretched canvas becomes a sort of drawing board.

When the drawing is completed, the time has come to transfer it to the canvas. Some sort of transfer paper is needed for this— something which can be employed between the original tracing paper drawing and the canvas. Ordinary carbon paper such as is used by typists will not do for the transfer of drawings, because

the carbon color cannot be covered up successfully with oil paints. Therefore, one often makes one's own transfer paper. This can be of a sheet of tracing paper of convenient size—possibly 20 x 24 inches. Into this tracing paper a dry pigment, such as red iron oxide, is rubbed with a rag. (This red dry color is obtainable in paint stores.) The iron oxide powder clings tenaciously to the surface of the paper, which may therefore be used for scores of transfers. When the color eventually becomes exhausted, some fresh dry pigment may be rubbed into the surface.

As a substitute, paper covered with charcoal dust may be utilized for transferring drawings to the canvas, but such paper can be employed for a few transfers only, because of the tendency of charcoal to rub off. One may also cover with charcoal dust the reverse side of an original drawing and effect a transfer without any additional transfer paper.

When the transfer paper has been prepared, it is laid on the canvas, with its pigment-treated surface in direct contact with the canvas surface. The tracing paper study (or any type of original drawing) is next placed in the proper position on the transfer paper, so as to bring the design into the right relationship with the rectangle of the canvas. To effect the actual transfer, every essential line of the drawing is now gone over with a pointed instrument, such as a pencil or the handle of a brush. This re-lining forces particles of the pigment to desert the back of the transfer paper in favor of the canvas surface, thus developing on the canvas a duplicate image of the design to be painted. Enough pressure should be exerted to effect a good tracing. The traced drawing may be fixed on the canvas with fixatif, sprayed on with a fixatif blower, or it may be gone over with an oil color (umber or Venetian red) thinned with turpentine or mineral spirits.

# CHAPTER XI: "SETTING" THE PALETTE

IT IS A GOOD THING to develop the habit of placing the colors on the palette—or of "setting" the palette, as it is often called—always in the same order, so as to be able to thrust the brush automatically in the accustomed direction. Nothing is more annoying than to scout all over the palette in search of a color. In what sequence the colors are arranged is immaterial, as long as one adheres to one system. For those who have not yet developed a fixed habit, I recommend the arrangement in Fig. 9.

Incidentally, a paint as it comes from the tube may sometimes prove to be too oily. To remove an excess of oil, spread the paint on an absorbent paper such as newspaper. After a few minutes the excess of oil will have been taken up by the paper.

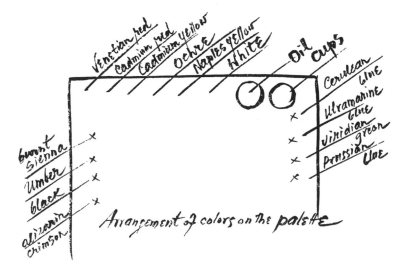

*Figure 9*

62

# CHAPTER XII: PAINTING A PORTRAIT

## *GENERAL CONSIDERATIONS: LIGHTING*

WITH THE PRELIMINARIES behind him, the student is at last in a position to gratify his ambition to undertake his first painting. As to subject matter, for this first work, I recommend the human countenance, though I realize that occasionally there are those who feel like shunning the portrait for a time in favor of the seemingly easier still life or landscape. In my opinion it is as well to muster the courage to try portraiture at once. The next few chapters discuss many of the essential considerations, and later chapters will present a typical problem in detail from start to finish.

## SIZE OF PAINTING

Whether one paints a head in life size, or in over or under life size, is a matter of taste. I believe that, for a portrait painting, life size is usually preferable. For painting a head and neck, the canvas may be 12 x 14 inches, 13 x 15 inches, or 15 x 18 inches. Head and shoulders may be placed on a canvas ranging in size from 13 x 15 inches to 20 x 24 inches. A half figure may be painted on 25 x 30 inches, or thereabouts. For a three-quarters length figure, 30 x 36 inches and up to 50 inches will do well. These suggestions refer, of course, to a more or less standard practice. Depending on the choice of a specific background, one may select a canvas of any desired proportion.

## POSING THE MODEL

It is advisable to place the model in such a position as to avoid looking upon it from above or below. The eye level of the painter should be at the same height as the eye level of the sitter, or, still better, the sitter should be a little higher than the painter. If a stage is not available on which to place the model, the painter should also work in a seated position; that is, if the model is seated.

Now, I do not want to imply that there is anything wrong in painting from a scaffold while the model sits on the floor, or in painting from the floor level while the model is placed on top of a staircase—such positions are often intriguing. But when painting a portrait, one has, as a rule, so many problems to solve that it seems to be reasonable to avoid complicating things more than is absolutely necessary.

## THE PROBLEM OF LIGHTING

Not only the position of a model, but the manner in which it is lighted is of utmost importance. The lighting of the model will determine to a great extent the appearance of the final painting, and a particular choice of light will reflect on the painters' imagination, artistic intelligence, and style. Style, especially, is strongly influenced by the manner in which light is used in a painting. In the following, I shall discuss all possible ways of lighting a model.

### 1. Light From a Side Window

This is the type of light most frequently used. (See 1, Fig. 10.) It affords excellent effects of light and shade. (The effects of light and shade are referred to as "chiaroscuro.") Although this simple manner of lighting a model is about five hundred years old, it still

*Figure 10*                    THE PROBLEM OF LIGHTING

serves the painter well and is by no means outmoded or common-place, while the more complex impressionistic kind of lighting, which is only about seventy years old, appears to be already antiquated. (See pages 69-70.)

As a rule, it is easier to paint a model thus turned toward the light source. If turned away from the light, the modeling of the face is more difficult to handle. (See 2, Fig. 10.) The beginner should also consider that the model should not exhibit too many shadows and too many glaring highlights. Strong highlights are unattractive, and to paint deep shadows successfully entails com-plications not only for the beginner, but even for the experienced painter.

In painting portraits, particularly those of children and young people, the use of shadows light in tone usually enhances the appearance of a painting. The more the source of light—i.e., the window—is narrowed to a small area, the more the light appears to concentrate on the object. Such a focal light will create strong contrasts of light and shade. Rembrandt had a similar lighting arrangement in his workshop. His light came through a relatively small window which was placed rather high in the wall.

If the model reveals too strong shadows, these shadows may be modified by placing a screen at the side of the model opposite the source of light. This will reflect light into the shadows of the model, lightening them. (See 3, Fig. 10.) Such reflected light, when skilfully managed, will influence a gloomy shadow agreeably. The color of the reflecting screen may also affect the color of the reflection.

## 2. Light From Two Sources

So far, we have discussed one source of light placed at the side of the model. Another way is to cast light on the model from two sources, one at each side. This type of lighting is rather old-fashioned

and was particularly favored by the academic Post-Impressionists. To achieve such a double exposure, the model is usually placed between the two sources of light, one of which dispenses generally a warm glow, and the other, a cold tone. The resulting effect is, in most instances, garish, and the figure painted in this manner lacks solidity and plastic unity.

### 3. Light From Several Sources

Still another method of lighting is to use light from several sources, applied simultaneously from different directions. Such spectacular lighting is, however, rarely advantageous, because it tends to produce flashy effects such as are seen in fashion and cinema photography. (See 4, Fig. 10.) The proof of my contention that spectacular lighting is not enduring may be seen when comparing an old-fashioned and simply lighted daguerreotype with a modern fashion magazine photograph. After one hundred years the noble simplicity of a daguerreotype is still esthetically acceptable, whereas our sophisticated modern photographers are mostly flimsy and lose their appeal with the passing of time.

Illustrators also use such complicated lighting for dramatic emphasis, but the aim of the illustrator is not identical with that of the portrait painter; therefore these different intentions should be kept in mind when contemplating the proper lighting for a portrait. Some fashionable portrait painters use, in addition to daylight, an alluring spotlight which, when placed in a strategic position, casts a so-called "glamorous" aura on an artistically disheveled coiffure, or a face, or a body contour.

### 4. Light From Above

To light the model from above is a very old practice. We see this exemplified in some of the Renaissance paintings; Leonardo

da Vinci was one of the first to use it with greatest effect. We see it in many portraits by Rembrandt, and some painters of later date; also French painters such as Courbet and Corot employed such light effects.

A light which thus comes directly from above is not necessarily advantageous for portrait painting, however, especially when the window—usually a skylight—is located high above the model. A face lighted from such a source reveals deep, gloomy shadows in the eye sockets, under the nose, lips, chin, etc., and this, in a portrait, may become quite disturbing.

## 5. Light From Below

A light from below is entirely artificial; it is usually associated with old-fashioned stage pictures. However, a reflection cast from below appears very frequently when the model is dressed in a light material. A white collar, for instance, as seen quite frequently in Dutch paintings of the seventeenth century, casts such strong reflections.

## 6. Plein Air

Lastly, we have another way of lighting a model, known as *plein air,* a French term originated with the Impressionists. In contrast to *studio light* (or chiaroscuro, as we called it), plein air indicates a light condition found out-of-doors. Such a light may be either direct sunlight or it may be diffused. We can dispense with the consideration of direct sunlight, because no one, I believe, will go today for sun-spotted effects. Diffused light, unlike direct light, does not create a clear division between light and shade. The plasticity of the object—its roundness or three-dimensional quality as expressed through the disposition of its light and shade elements—is consequently not aided much by such lighting. The modeling of

a face under diffused lighting relies on a rather delicate differentiation of tonal values. In his characteristic work, Whistler, in painting portraits, relied on such tonal values. The modern French school often employs diffused light, their idea being that "pure color" may be more adequately realized when shadows do not veil such colors. However, I would not put too much stock in all of the esthetic premises of the contemporary L'Ecole de Paris.

A diffused light may be found indoors as well as out. In any room, away from the focus of light which comes through a window, a more or less diffused lighting condition will prevail.

The six different ways of lighting described on the preceding pages exhaust all the possibilities of lighting a model—except perhaps the possibilities which an artificial light may offer. However, since my descriptions are mainly based on personal experiences, I do not attempt to discuss artificial lighting, because I have never painted, nor have I ever found it desirable to paint, under an artificial light.

After having described and commented upon all possible manners of lighting a model, by now the reader has become well aware of my personal likes and idiosyncrasies. However, the student must not necessarily be guided by these. Such considerations are, as I have mentioned, a matter of the style which one adopts, and the task of this book is not to shape or influence the reader's esthetic allegiances.

No matter what light one may choose, it is desirable that one's own shadow, or the shadow of one's arm, is not cast on the canvas. Thus, it is most comfortable to paint with the light coming from a window at one's left.

# CHAPTER XIII: PAINTING A PORTRAIT

## *FLESH TONES*

TURNING NOW to a consideration of our paints, it is conceivable that one may use, for painting flesh tints, almost any combination of colors, but the painter will do well to restrict his color range at first to simple color schemes which will simplify rather than complicate his problem.

The following range of colors will produce endless variations of tones with which one may paint the lightest and the darkest complexions, depending on the predominance of one or another color.

1. White, yellow ochre, Venetian red, ultramarine, umber
2. White, yellow ochre, burnt sienna, ultramarine (or black)
3. White, yellow ochre, Venetian red, umber
4. White, yellow ochre, umber, ultramarine

(See Color Plate 3, page 76, and graph opposite it.)

The first-named color combination alone will produce any desired flesh tone, but the painter may want to use some different color combinations for the sake of exploring other possibilities of color treatment.

Let us now discuss the chief colors and examine their usability for the purpose of painting flesh tones.

When I refer to white, I have in mind white lead color and not zinc white.

Of all the yellow colors, ochre is best for painting flesh tones. Cadmium yellow is inappropriate because of its aggressive hue. The high key of this color may easily throw the other colors used for flesh tones out of harmony. Although cadmium yellow is fre-

71

quently employed by some painters for flesh tones, nevertheless I do not recommend it. Naples yellow, in spite of its mild yellow hue, is a cold color and difficult to combine with other colors for flesh tones.

Of all our red colors, Venetian red is the most agreeable in mixtures for flesh tones. Cadmium red has too high a key to be easily co-ordinated in the general color scheme; also, its tendency to turn violet in mixtures with white and blue is most unwelcome.

Our only dark brown color—umber—is the most frequently used in mixing tones for shadows. Umber may easily be brightened with Venetian red and yellow ochre, or darkened with ultramarine.

Ultramarine is an almost indispensable color in painting cool shadows. Neither Prussian blue nor cerulean blue will do as well for this purpose. The first is too powerful and the latter too opaque. Ultramarine mixed with umber (without white) may substitute for black. With yellow ochre and umber, ultramarine will yield greenish nuances. Sometimes one may substitute black for ultramarine in painting shadows.

Pure white color will be used for highlights. For painting flesh, white color will be modified with yellow ochre, or light red or both, depending on the color of the complexion. For cold nuances, white may receive a slight addition of ultramarine blue. A lifelike appearance will be promoted by the use of warm colors. Reflections on the skin painted in Venetian red and yellow ochre will greatly add to the realism of a portrait. Such fiery reflections are often found on the portraits and figure paintings by Rubens, Frans Hals, and on portraits by Raeburn, Lawrence, and others. The cooler the flesh tone, the less pronounced becomes the realism of the painting. Flesh tones painted entirely in blues or greens suggest "abstractions" because we do not associate such colors with lifelike appearance.

For painting lips, Venetian red, yellow ochre and white, or

alizarin crimson with Venetian red, yellow ochre, and white will provide a wide range of colors for the light areas; Venetian red, or alizarin crimson with ultramarine, or umber may be used for the areas in shadow.

In most of the classic examples of portrait and figure painting, one may observe that the lights are painted in an opaque fashion, sometimes even with considerable impasto, whereas the shadows are painted thinly. Sometimes these shadows are mere glazes which reveal to a lesser or stronger degree the underlying color. Of course, the light passages cannot be painted in a transparent fashion, because the white color does not lend itself to any other but an opaque application. Other colors mixed with white will also appear opaque. The more recent schools of painting—that is, most of the schools of the past century—generally do not differentiate much between opaque and transparent applications. The shadows and the lights on such paintings are treated in the same fashion.

It is not necessary to try to decide which school is the better one, but I expect the painter to be fully aware of the manner in which he paints—that he know the possibilities which his materials offer. In other words, the painter's intentions should be commensurate with his means. Unfortunately, as we all realize, the art of painting today is, with many painters, more a matter of following a whimsy than of following a discipline and the rules of craftsmanship. One of our leading art critics once wrote "He who knows how to paint a chair can paint a picture." I doubt whether the nonsense revealed in this statement can be surpassed.

# CHAPTER XIV: PAINTING A PORTRAIT

## *HOW TO PAINT HAIR*

How to paint hair is, I confess, a rather funny-sounding subject for discussion. Everyone knows that "brunette" hair is brown, "blonde" is yellow, etc. However, I remember that it did not appear to me to be funny at all when I tried to copy, in the Imperial Museum in Vienna, a Flemish painting of a man with a red beard. Everything went well until I attempted to match the red color—and missed—no matter which red I pulled out of my paint box to match the fellow's whiskers. Almost thirty years have passed since this futile struggle with an auburn beaver, and I still remember my helplessness. And so this chapter "How to Paint Hair" is offered with the hope that it may save someone from equally painful frustration. For illustration, see Color Plate 3, page 76, and the graph opposite it.

When painting blonde hair, cadmium yellow will hardly be the best color. In mixture with yellow ochre and white, cadmium yellow will yield the proper hue, but in such mixtures it will greatly resemble Naples yellow, which is altogether the best color for painting light hair. Often, however, Naples yellow, as sold in tubes, is not genuine. (If it isn't, a statement to this effect should be found on the tube.) Even when it is stated to be genuine, Naples yellow in tubes has an extremely pale hue. The Naples yellow which one may buy in dry pigment form is by far more powerful; the reason why a strong Naples yellow paint is not put into tubes has never been made sufficiently plausible to me. To improve the pale color of Naples yellow, one may have to mix with it a small quantity of cadmium yellow. In painting shadows on light-colored hair, umber will be quite suitable, especially when

74

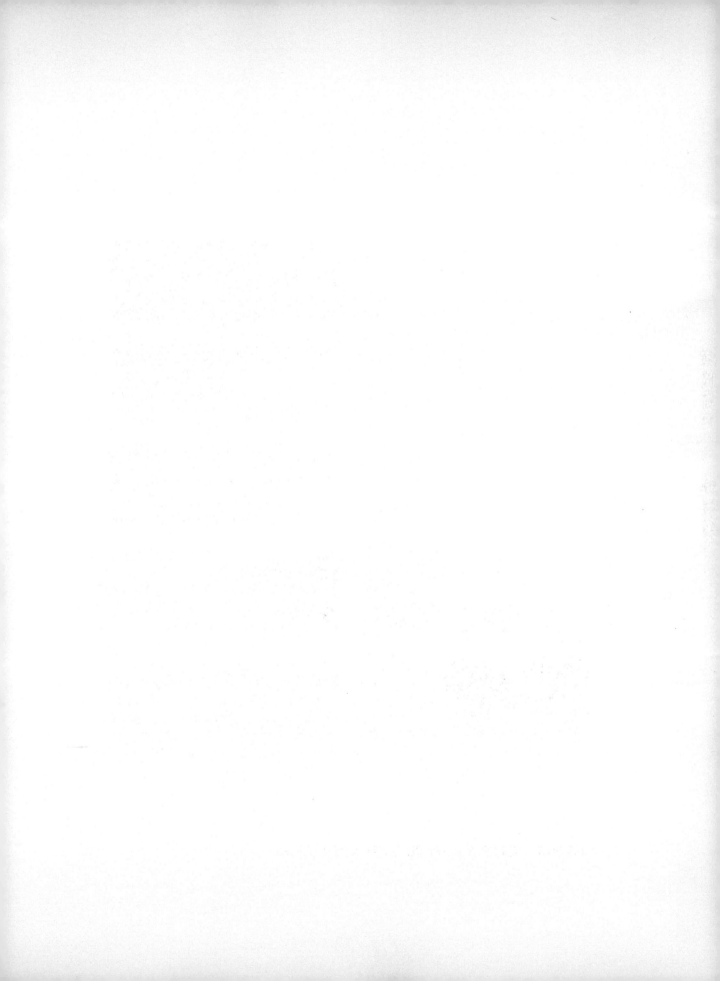

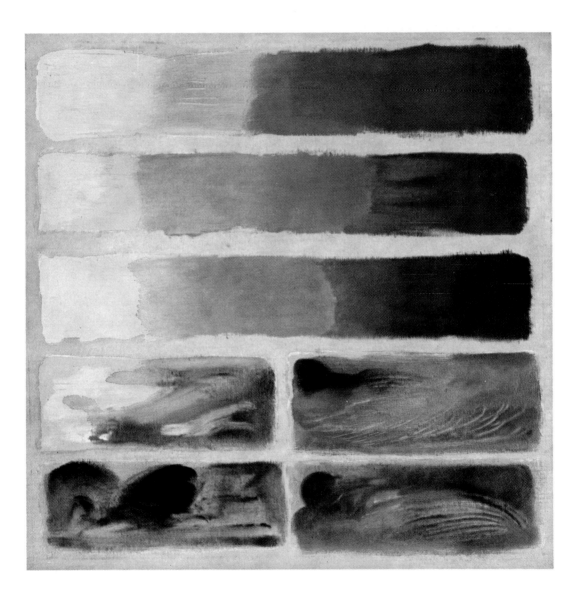

COLOR PLATE 3—FLESH AND HAIR TONES

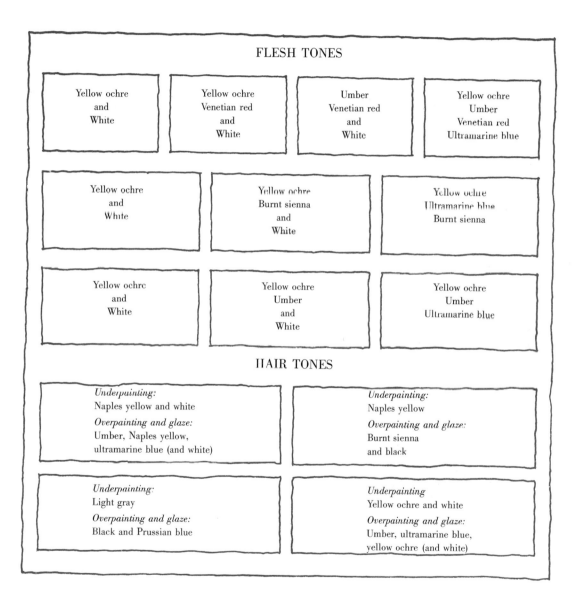

FLESH TONES

| | | | |
|---|---|---|---|
| Yellow ochre and White | Yellow ochre Venetian red and White | Umber Venetian red and White | Yellow ochre Umber Venetian red Ultramarine blue |

| | | |
|---|---|---|
| Yellow ochre and White | Yellow ochre Burnt sienna and White | Yellow ochre Ultramarine blue Burnt sienna |

| | | |
|---|---|---|
| Yellow ochre and White | Yellow ochre Umber and White | Yellow ochre Umber Ultramarine blue |

HAIR TONES

| | |
|---|---|
| *Underpainting:* Naples yellow and white *Overpainting and glaze:* Umber, Naples yellow, ultramarine blue (and white) | *Underpainting:* Naples yellow *Overpainting and glaze:* Burnt sienna and black |
| *Underpainting:* Light gray *Overpainting and glaze:* Black and Prussian blue | *Underpainting* Yellow ochre and white *Overpainting and glaze:* Umber, ultramarine blue, yellow ochre (and white) |

*GRAPH FOR COLOR PLATE 3 (Opposite Page)*

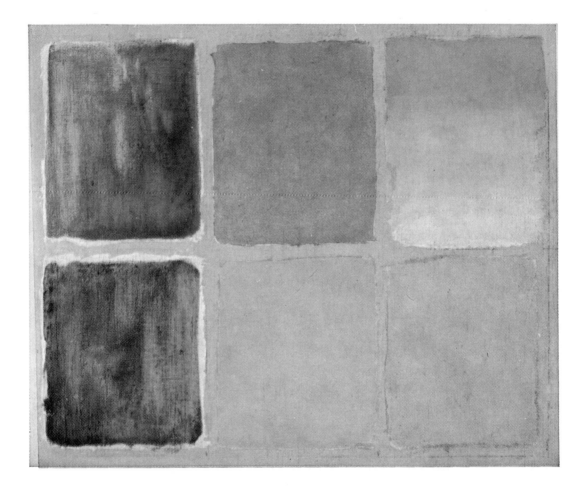

*COLOR PLATE 4—IMPRIMATURA AND TONED GROUNDS*

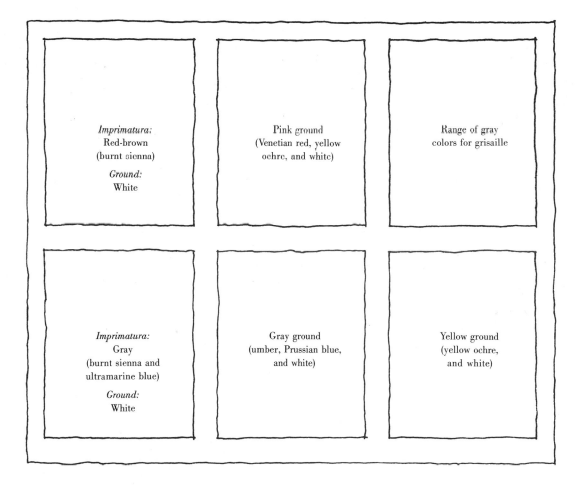

*GRAPH FOR COLOR PLATE 4 (Opposite Page)*

used as a glaze on an underpainting of Naples yellow. (See Color
Plate 3.) The highlights may then be painted into the wet umber
glaze with Naples yellow and white. Also, the Naples yellow
underpainting may be relieved by scraping off the (wet) umber
glaze in places where light effects are desired. Besides umber,
which is a warm color, often the cold ultramarine blue may be
needed to produce a proper shade on light hair. And lastly, burnt
sienna may prove to be very useful for glazing warm, glowing
color passages in both light and shadow areas.

For painting red hair, cadmium red, as well as the red iron
oxides (Venetian and Indian red), are as a rule inappropriate, and
cadmium yellow and orange mixed with these colors do not improve
the situation. I refer here again to realistic representations. If
realism is not sought, red hair may take the appearance of flames
shooting out from a volcano, for that matter. For realistic repre-
sentation, however, burnt sienna will be the most suitable for all
the hues of red hair—from light copper to brownish red. The
variations in the appearance of the burnt sienna paint will be pro-
duced chiefly by the differently colored underpainting. The above
indicates that burnt sienna will be used in a glazing, transparent
fashion, at least in the lighter areas. The darker and denser areas
will receive a more pastose application of burnt sienna, and, for
darkest effects, black may be mixed with it.

As to the underpainting for the red color scheme, it may range,
depending on the case, from the palest gray or yellow to orange
and brown. A pale, warm gray for the underpainting may be pre-
pared from umber and white; a yellow underpainting from yellow
ochre and white, or Naples yellow and white. Also cadmium
yellow and cadmium orange (and white) may be used in under-
painting when especially strong red hues are sought. Highlights on
such hair may be derived either from the underpainting—by
scraping off the wet top paint, thus revealing the underlying color

—or they may be painted in with white and Naples yellow, or with cadmium yellow and white, depending on the intensity of the color of the hair.

For painting brown hair, a combination of yellow ochre, umber, and black will provide the proper hues; often an addition of burnt sienna will be needed. Underpainting will not play a deciding role when using this combination of colors because they will mostly be applied in an opaque fashion. In such an instance, underpainting may be prepared from white and yellow ochre, or white and umber, etc.

When painting black hair, one may either derive the lights (also highlights) from the underpainting, or the lights may be brushed in pastosely. In the first instance, the color of the underpainting will have to be identical with the color of the lights. For a cold color range for the underpainting, as well as for the painting, an addition of Prussian blue to the ivory black will be appropriate. And for a warm color range, umber may be added to the black.

*Addenda:* The reference to the inadequacy of the Naples yellow in tubes was made some time ago. Today a deep-colored Naples yellow is obtainable in trade.

# CHAPTER XV: PAINTING A PORTRAIT

## TREATMENT OF THE PAINTING GROUND

I SHALL DEFINE in the following paragraphs these ominous-sounding words which have so far appeared only in the Table of Contents—*imprimatura, toned ground, underpainting.* Thus they will lose their seeming complexity.

The word "imprimatura" stems from the Italian, and its meaning is "staining." The stained surface in this case is the white painting ground. (See Color Plate 4, page 78, and graph opposite.) Such a stain is but a glaze such as we have already discussed, so a glaze on a white ground can be defined as imprimatura. As a rule, imprimatura is quite transparent and free from admixtures of white.

### Colors and Media Used for Imprimatura

The warm colors for imprimatura will be prepared from burnt sienna applied to the white painting ground in the thinnest fashion, using a bristle brush. This thin color may either be painted evenly all over the surface, or it may be slightly varied in transparency according to one's taste. For painting portraits or figures, burnt sienna is the most suitable color for imprimatura. Also, at times, a gray imprimatura may be desired, and such a gray color may be obtained from mixtures of ultramarine and burnt sienna. (See Color Plate 4, page 78.)

Copal resin varnish is the best medium for thinning the colors to be used for imprimatura because it possesses great binding power and dries rapidly.

Turpentine, when employed as profusely as it has to be in order to thin the paint, will not have the power to attach the color firmly

83

to the painting ground. Linseed oil is not an appropriate medium for imprimatura, because, when applied abundantly, this fatty medium will create a surface which is entirely unsuitable as a painting ground.

Upon the application of the imprimatura, the painting of a portrait may proceed immediately, or one may prepare an imprimatura foundation ahead of time. Imprimatura will be used chiefly on small canvases up to about 16 x 20 inches, and on a canvas ground which is rather smooth. On a coarse-surfaced painting ground, imprimatura application is ineffectual.

I referred to copal varnish as the only suitable medium for imprimatura. However, there are many kinds of "copal" products on the market, the compositions of which radically differ from the Permanent Pigments product I recommend.

The damar resin solution is not adaptable for imprimatura, for it will always dissolve under the action of the painting medium. The copal varnish, on the other hand, solidifies sufficiently after two days to resist such a solving action.

## Toned Ground

A toned ground is an opaque solid color executed on the white canvas ground. It consists chiefly of white lead color toned to a desired hue with some yellow ochre, gray, or pink. For portrait painting, a gray color is most suitable for the ground because it contrasts well with warm flesh tones. An important consideration is to keep the color of the ground in a light hue as indicated on Color Plate 4. Toned grounds must be prepared in advance, because a painting should proceed on a well-dried foundation. A thin, gray ground prepared from such quick-drying colors as Prussian blue, umber, and white lead will be sufficiently dry in a few days. An addition of siccative (see page 33) will make any thin ground

dry out in less than 24 hours. The ground should be applied to the canvas very thinly and evenly, using a palette knife. Paint texture or roughness of the ground may sometimes be very disturbing if they strike through the overpainting.

## *Underpainting*

Underpainting is but a modified toned ground; i.e., different colors are applied to different areas of the painting. Generally, as in the case of toned grounds, the color of the underpainting will be light and of a low key. White lead will be the chief constituent. It is practical to apply the underpainting to the canvas with a palette knife. However, when underpainting small areas, this is not always feasible. At times one will use a bristle brush and smooth out the marks of the bristles with a soft sable brush or the palette knife.

As in toned grounds, the paint used for underpainting should be as stiff as possible; that is, it should not be diluted with oil. A paint which is too stiff to be managed with a brush may be loosened up with Copal Painting Medium to a usable consistency.

One may use for the toned ground and the underpainting a commercial white lead as sold in cans, and mix it with the colors as required.

The method of underpainting will vary, depending on subject matter. As the book progresses, I shall discuss several variations, in relation to portrait, still life, and landscape painting.

# CHAPTER XVI: PAINTING A PORTRAIT

## *SIMPLICITY VS. COMPLICATION*

THE PREPARATIVE MEASURES which I have described in the preceding pages may seem to the beginner to be quite complicated. The fact is, however, that these measures, once they are fully understood, form the basis of methods which are more simple than any others which are commonly practiced.

We hear sometimes that the use of an underpainting is a "special" approach, in contradistinction to the "direct" painting method. To demonstrate that this is erroneous, let us scrutinize the process of a so-called "direct" painting. The painter transfers his impression of the object, in paint, directly to the white canvas. When he lets the work stay as it appears after it has been painted "wet-in-wet" during one session, or at least during a period which permits the color to stay wet, we may truly speak of a direct painting. But, as a rule, the initial painting will have to be gone over to correct mistakes, improve colors, etc. By the time this is done, the initial painting will doubtless have dried, so the painter will proceed with his work on the dry painting. At this point, the direct method ceases to be direct; in fact, the painter actually works on an underpainting, but his underpainting is not planned and purposeful —it is merely an unsatisfactory, faulty painting. If we consider here that a superimposition of identical colors results as a rule in opacity and dullness, and if we furthermore consider that glazes can be effected only when a proper foundation is first prepared, we may easily recognize that using a "direct" method all too commonly means painting without a method at all. It's merely a hit-or-miss approach.

Painting directly on a white ground without previous preparation, as is so commonly done today, is a relatively new procedure, since the Impressionists were the first to abandon underpainting. For an impressionistic approach such a procedure is logical. On the other hand, the classic school of painting always employed the methods which I describe in this book. As to the modern school, as a rule no one seems to bother about any method. Or, I should say, perhaps, no one *did* bother to follow a method, because lately there seems to be quite a concern among younger painters to return to principles of a sound and noble craftsmanship.

# CHAPTER XVII: PAINTING A PORTRAIT STEP-BY-STEP

## *THE MAIN CONSIDERATIONS*

OUR PRELIMINARIES ARE NOW behind us; we are ready to proceed with our first portrait. The accompanying step-by-step illustrations, together with the written discussion, should prove as helpful a guide to the student as can be offered on the printed page.

### *Drawing*

When a painter is not sufficiently skilled to sketch his model's likeness directly on the canvas, he should first make a portrait study on paper, later transferring the major proportions to the canvas in the manner already described in Chapter X. For convenience, tracing paper is often used for this sketch. Sometimes this is laid across the canvas (which serves as a support) and is thumbtacked to the stretcher strips until the work is finished. The complete sketch may be in outline or in full values; when it is transferred, only the main outlines are needed.

In Fig. 11,A, we see such a portrait study, though in this instance it was carefully executed in full values in charcoal on charcoal paper. This may be considered as a typical preliminary study of the sort just recommended—a study such as one can always advantageously make to acquaint oneself with the features of the model.

At B, the drawing has been traced in outline from A and transferred to a canvas with a toned ground which is in our case of a gray color. As we see, this traced drawing does not attempt a modeling of the head.

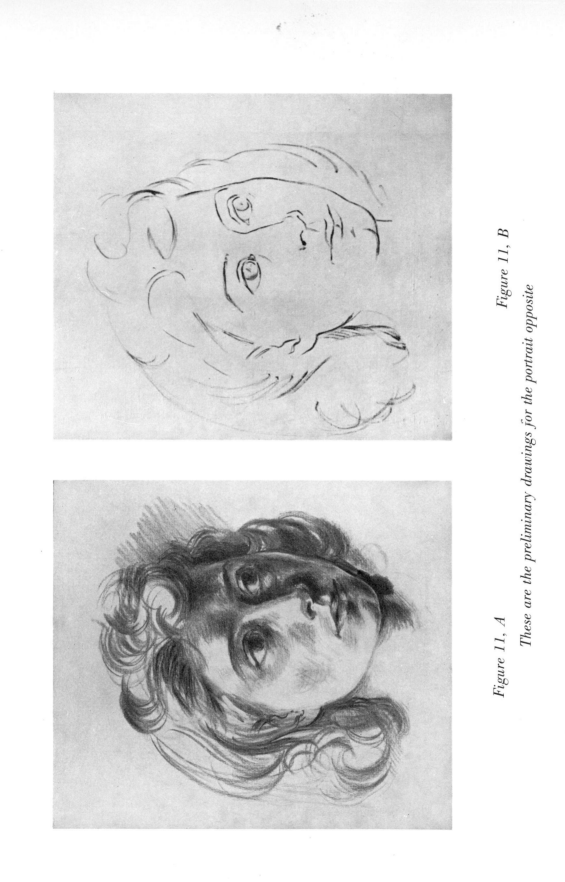

Figure 11, A

Figure 11, B

These are the preliminary drawings for the portrait opposite

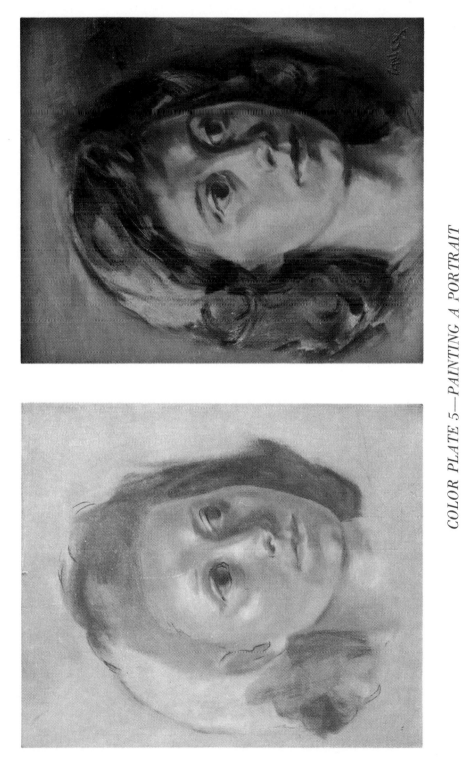

*COLOR PLATE 5—PAINTING A PORTRAIT*

At the left we see the underpainting in grisaille—
at the right the work is completed

In case an imprimatura is planned, one's drawing should be transferred to the original white canvas ground, and the transparent imprimatura should be applied on top of it. Often the traced drawing will not be distinct enough and so will need reinforcement. Such re-drawing may be carried out in charcoal; it may then be "fixed" with fixatif. Or India ink may be used for drawing on the canvas. (One should take into consideration, however, that India ink is indelible, so corrections cannot easily be made when working with this medium.) The usual way of re-establishing the drawing on the canvas is to go over the contours with a turpentine-diluted oil color. This color may be umber or any of our iron oxide reds. For drawing, use a small, round, sable brush. Unless such a drawing, executed with a turpentine-diluted color, is a week old or more, it may be dissolved by the subsequent imprimatura. Therefore, India ink is a more appropriate medium to use when an imprimatura is to be superimposed.

When one plans to paint on a toned ground, the drawing is transferred onto this ground—which must be thorougly dry—and not to the bare white canvas, because in the latter case the transferred drawing would become indiscernible under the subsequent application of the ground. With the transfer made, the drawing may next be gone over with a turpentine-diluted color.

When one uses an underpainting, the drawing should be transferred to the original white canvas ground first (or to the toned ground—one may underpaint on the toned ground as well). This tracing may either be fixed with fixatif or gone over with a turpentine color.

### Painting on Imprimatura

For the sake of clarity I shall repeat the first two moves before going on with the rest.

1. Transfer the drawing to the panel, a support which is better for painting on imprimatura because of its smooth surface. (Canvas, on the other hand, because of its grain, is more suitable for underpainting.)

2. Make the drawing indelible by means of fixative, and cover the entire surface with burnt sienna or viridian green imprimatura.

3. With a bristle brush, rub a little painting medium onto the surface of the panel. Using imprimatura, the more viscous copal painting medium heavy is the best choice. As mentioned before, allow the copal varnish imprimatura to solidify for at least two days, so that it will not be dissolved by the painting medium (which contains a certain amount of turpentine). Why should one apply the medium before painting? First, to reduce the friction between the brush and the surface to be painted; and second, to improve the adhesion of the subsequent paint layer. Moreover, this procedure allows the painting to dry with a better gloss, largely circumventing the sunk-in appearance of colors.

4. Start to paint the shadows where seen on the model's face, but observe the precaution of painting these shadows in a somewhat lighter key than they appear.

5. Proceed to the lights but refrain from applying the lightest colors and the highlights.

From the above, it is obvious that the student should not at the start "commit himself," so to speak, with the deepest shadows or highlights. The strongest accents should always be painted in last.

One reason for painting in a lower key is that in case he resumes his painting the next day or in a few days (that is, on the dry preliminary sketch), the light-colored sketch will lend itself very well to overpainting. When referring to a "light-colored sketch" I mean a sketch which is lighter in the shade areas than the finished

painting will eventually appear. But the areas of the head which receive the full impact of light may be painted in somewhat darker tone because they will be overpainted with the entirely opaque white lead color. As a matter of fact, it is easier to paint highlights on a darker ground.

Before discussing the working up of the features and final details (see Chapter XVIII), let us pause for some important considerations.

First, the background may (or may not) be painted simultaneously with the head, because the color of the imprimatura may serve as a preliminary color for the background.

When one is unable to finish a painting in a single sitting (that is, painting "wet-in-wet"), one should paint in a thin fashion and not with impasto. Impasto is not advisable because a thickly painted surface will need considerable time to dry sufficiently for overpainting, and because a rough impasto will make overpaintings difficult. Of course, one may smooth such an impasto with sandpaper, but this may be done only when a paint layer is dry throughout. A thick layer of paint may remain wet within (under the hardened skin) for a considerable length of time.

Before one starts to overpaint a sketch which has dried, it will be necessary to re-establish the true appearance of colors which may have gone flat and dull. These sunk-in colors will regain their original hue when some of the painting medium is rubbed into the surface. This procedure is called "oiling." Sometimes, oiling does not spread evenly on the surface; the medium contracts, forming little droplets, a condition known as "trickling." (See page 31) To prevent this, brush some turpentine onto the surface before oiling.

To utilize the full value of the imprimatura and to exploit the effects to which it lends itself, it is best to paint on it predominantly in a semiopaque fashion so as to reveal the existence of this imprimatura in some parts of the painting. Therefore, it is best to finish a painting in one sitting, and this will help to preserve the

character of sketchiness. For quick, sketchy work, the use of imprimatura seems to be better adapted than any other method, especially when painting on a small canvas or board.

### Painting on Toned Ground, and Underpainting

Painting a portrait on toned ground—preferably a light gray ground—or underpainting the portrait in neutral colors will not call for a different technique. The only difference between these two approaches is that the work on a toned ground will progress at a much quicker pace.

After the drawing has been transferred to the canvas, it may be reinforced with charcoal and then fixed with fixatif. It may also be redrawn with a thin turpentine color such as light red, umber, or burnt sienna. When using a tracing paper which has been prepared with an iron oxide pigment (see page 61), the tracing will often be so firmly attached to the canvas that it need not be re-drawn or fixed. On this drawing, the underpainting is executed in light, neutral colors. "Neutral" designates a color which is more or less gray. This painting in grays is called "grisaille." As a rule, grisaille has a cold color-range, but one may employ a warm grisaille as well; since our grisaille is prepared from Prussian blue, umber, and white, the predominance of the blue or the brown color will determine the tonal value of the grisaille. Yellow ochre may also be added to this combination in order to liven up a neutral under-painting when desired. Here the painter has considerable latitude in the choice of his colors, and the only principle which must be observed is to keep the underpainting in a light key.

On the third rectangle of Color Plate 4, page 78, I have indicated the range of gray colors from white to a dark gray. Even this darkest gray will be relatively lighter than the darkest shadow on the face of the model. On Color Plate 5, page 91, the underpainting (at left) was executed in a rather cold color scheme; the hair

was underpainted in Naples yellow, yellow ochre, burnt sienna, and white, and the background remained untouched; that is, it retained the original gray color of the toned ground. So the grisaille was executed on a canvas which was first covered with a light gray color.

Let us now consider the advantages which this toned ground offers to the painter in furthering the progress of his work. The gray tone of a ground may be considered the middle tone of the underpainting. By heightening this middle tone with white (for the lights), and by deepening it with a darker gray (for the shadows), the modeling of a painting may easily be achieved. Also the underpainting of a background may be omitted entirely since the gray color of the toned ground will serve as an underpainting for the final painting of the background.

Toned ground should not, however, be applied to a very smooth canvas, because a smooth canvas will thus become too slick to receive further overpaintings.

The paint used for underpainting should be as stiff as possible; that means it should not be diluted with the painting medium. Too stiff a paint, however, may be thinned with a little copal painting medium as mentioned on page 85.

It is important that the contours of the underpainting be well blended. Hard transitions of light and shade areas, or the outlines, will prove to be disturbing when finishing a painting.

The principal merit of this neutral underpainting lies in the fact that subsequent overpaintings may be carried out on it without the risk of making the final painting appear muddy and labored. Should the painter apply successive layers of identical *natural* colors, one on top of the other, he will invite dullness of colors and technique. Now the question arises—why should one altogether resort to overpaintings? The answer is that corrections necessitate overpaintings. If one has not succeeded in establishing a satisfactory modeling and likeness in one sitting, one will have to resort to

overpainting. Of course, it would be an ideal condition to finish a portrait in one single sitting, but to do this one would have to be extraordinarily skilled, and in this case he could dispense altogether with grisaille and paint in natural colors from the start, on an imprimatura or on any desired toned ground. As a rule, even an experienced painter will not be able to achieve a satisfactory likeness easily, and thus the use of neutral colors for an underpainting will serve him well. After a likeness has been established in neutral colors, one may proceed to give attention to the natural color without much danger of losing the likeness.

Before starting to paint on the dry underpainting, its surface (that is, only the areas to be painted) should be slightly moistened with the painting medium. The medium can be rubbed onto the canvas with one's fingers, or a stiff brush may be used. One need not necessarily paint the entire face in one sitting, but he may proceed to paint in a piecemeal fashion, first painting the forehead, next the eyes, etc., always observing the principle of working on the shadows first and the lights last. As a rule, it is advantageous to paint the hair after finishing painting the face in order to aid the expression of the face by the proper treatment of the hair.

The painting reproduced on Color Plate 5 was executed in the following colors: Flesh tones—white, yellow ochre, Venetian red, umber, ultramarine blue. Hair—Naples yellow, burnt sienna, umber. Background—Prussian blue, yellow ochre, umber. Bristle brushes and flat and round sable brushes were used for painting the face. The background was executed with palette knife and flat sable brushes.

# CHAPTER XVIII: PAINTING A PORTRAIT STEP-BY-STEP

## THE DETAILS AND BACKGROUND

Now, COMING TO such details as the eye, ear, and mouth, we shall discuss each in turn, giving attention also to the treatment of the contours and the background.

### Painting of the Eye

When painting a small area composed of intricate shapes, it is best to cover the entire area first with a unified tone before attempting the details. Here, for example, is the procedure when painting the eye. (Fig. 12, A, B, C.)

A.  Cover the area 1 with the darkest tone of the eye white.

B.  Paint into this wet color the iris (2).

C.  Paint the pupil, the lights, and the highlights of the eye in the order indicated by 3, 4, and 5. Blend the contours.

Since all these details are executed into a wet surface, a certain softness of the contours will result, even without blending; the blending itself will be greatly facilitated if one proceeds in the manner described above.

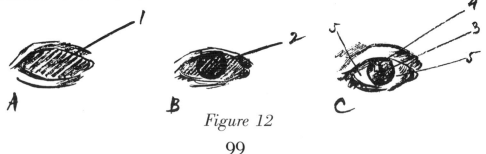

Figure 12

99

*Painting of the Ear*

As demonstrated at A, Fig. 13, paint the middle tone of the ear (that is, the tone which is neither the shadow, nor the light—just in-between) over the entire area of the drawing.

Next paint the shadows and strong accents into the middle tone, as shown at B, and, finally, paint lights and highlights wet-in-wet as demonstrated at C.

*Figure 13*

*Painting of the Mouth*

Here the difficulty for the beginner is to paint the lips as a part of the face, and not to treat them as if they were an alien element painted into the face, as they are at A, Fig. 14. To avoid an effect of a "painted on" mouth, the contours of the lips should be blended with the color of the surrounding flesh. (See B, Fig. 14.)

In order that the painter may realize the true appearance of lips, the female sitter should remove the lipstick which conceals the

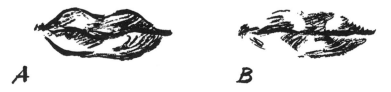

*Figure 14*

natural delicate color nuances and reflections on the lips.

The blending of the color of the lips and the flesh tint is more difficult when the color of the lips is mixed with alizarin crimson. This color, when combined with the white of the flesh tint, yields an alien, unpleasant violet. As a matter of fact, one can dispense entirely with this color, using Venetian red instead.

## Painting Contours

One of the major tribulations in painting is the treatment of the contours or outlines of objects. Such a contour or outline may be the border line where the object and the background meet; the border line dividing the hair from the forehead, the eyebrow from the eyelid, the chin from the neck, etc. When these border lines or contours appear sharply defined, we speak of a linear approach, but painting soft contours is considered to be more painterly. (See Fig. 15, A and B, page 102.) The manner in which one treats the contours is to a great extent dictated by existing fashions in art. The precise, hard outline has been used, and, for that matter, is still used by some painters, for various reasons.

Some painters prefer a soft contour, and some blur and fuzz the outlines in an excessive manner. Which is the "proper" way to treat the contours? It is my opinion that any preconceived idea about the treatment of the outlines must necessarily be wrong because such ideas are directed toward creation of a style, but a style is not the product of an esthetic conspiracy. The treatment of a contour should depend on the painter's feelings about the outlines as they impress him, conditioned by light, color, and the necessity for emphasis or restraint.

After the esthetic experience which many centuries of painting have given us, it is safe to say that neither a uniformly hard nor

*Figure 15, A—HARD CONTOURS*

*Figure 15, B—SOFT CONTOURS*

a uniformly blurred contour is desirable. But the student cannot expect to solve this intricate problem easily; therefore, it is best for him to limit himself to an over-all soft treatment of contours, and to modify the procedure with the gain of experience.

## The Background

Since the background often covers large portions of the painting, it will contribute to a lesser or stronger degree to the general appearance of the painting.

When painting a background, the following principles should be observed: The background should aid the plasticity of a figure. It should not dominate the figure through colors and the effects of light and shade; this implies that the background should not be more active than the main motif. When painting the background, one should keep in mind that its function is to aid and to emphasize the main motif. This is the reason why it would be a mistake to paint the background first and the figure last; so long as the figure is not finished, the background should be neutral—non-committal. When the main motif has advanced far enough, finishing of the background may proceed. The final co-ordination of a background and a figure may then be carried out.

A background for a portrait may be anything from a backdrop, a piece of cloth, a void, a kitchen interior, to a Grand Canyon panorama. Since a discussion of the endless possibilities is rather futile, we shall consider the principles of the background function in relation to the figure, assuming that the background is an empty space influenced by light and shade. The following are the characteristics of the backgrounds which are demonstrated on Figs. 16–20.

Fig. 16. Dark background and light appearance of the figure.

Fig. 17. Dark silhouetted figure on light background.

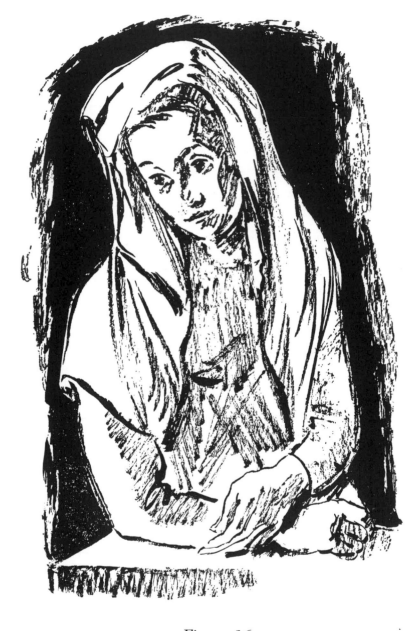

*Figure 16*

Dark background and light appearance of figure

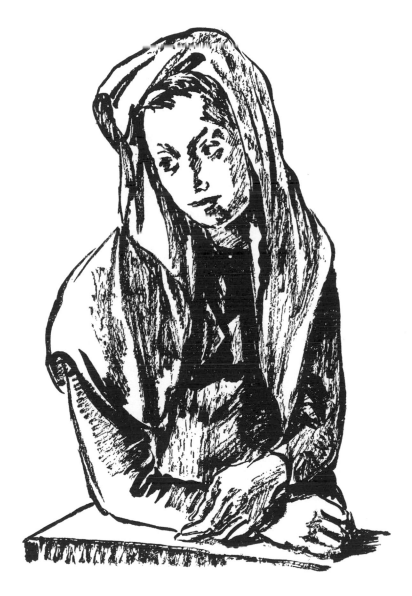

*Figure 17*

Dark silhouetted figure on light background

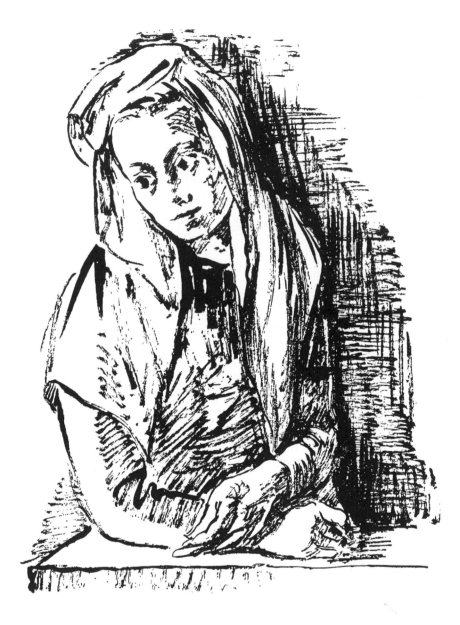

*Figure 18*

Shadows of the figure blending with shadows of the background:
lights of the figure blending with lights of background

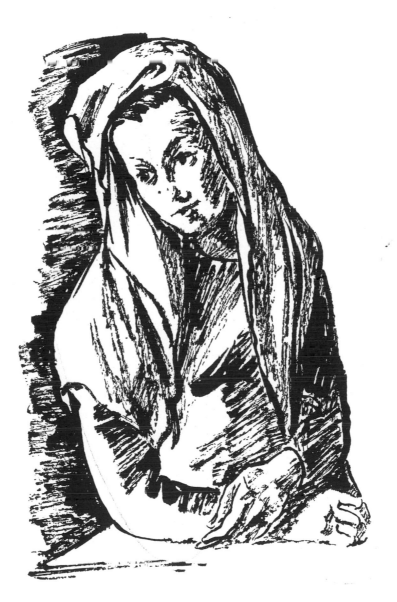

*Figure 19*

Dark masses against light masses and vice versa

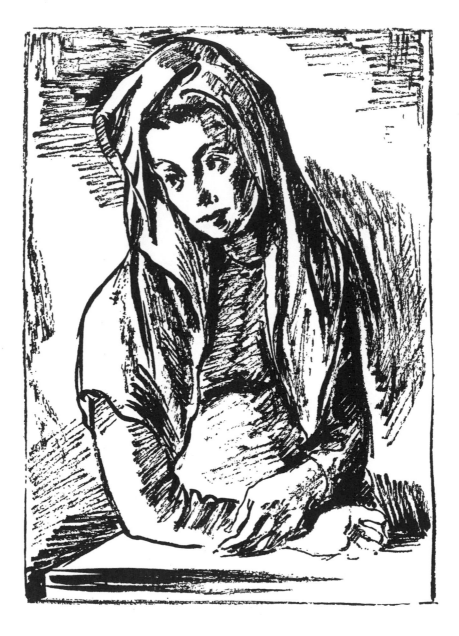

*Figure 20*

Irregular distribution of light and shade aiming at dramatic emphasis

Fig. 18. Shadows of the figure blending with the shadows of the background, and the lights of the figure blending with the lights of the background.

Fig. 19. Dark masses against light masses and vice versa.

Fig. 20. Irregular distribution of light and shade, aiming at dramatic emphasis.

Simple colors of neutral character will usually be more suitable for the background of a portrait than complex or brilliant ones. I don't mean to say that a stark red, yellow, green, or other strong color should be ruled out for use in backgrounds. But the perfect co-ordination of strong colors of a background into the general color scheme of a painting entails certain difficulties. The beginner would therefore do well to acquaint himself first with simple color combinations, a few of which I list here:

White, yellow ochre, black
White, yellow ochre, ultramarine (or Prussian blue), black
White, yellow ochre, Prussian blue, umber
White, yellow ochre, Venetian red, viridian green
White, cadmium yellow (or orange), black
White, Naples yellow, black
White, Naples yellow, black, umber

As we see, these colors represent combinations of warm colors—yellow ochre, cadmium yellow, Naples yellow, Venetian red, umber—and cold colors—black, ultramarine, Prussian blue, viridian green. The variations which may be achieved with these simple colors are endless.

What tools should be used for painting the background—whether bristle or soft brushes, or the palette knife—depends on the texture which one plans to effect. It is best to start painting the background with a rather large bristle brush; in the final stages soft hair brushes or the palette knife may be advantageously employed.

# CHAPTER XIX: PAINTING FLOWERS

THE PRINCIPLES which govern the painter's work remain basically constant regardless of the subject matter which he may choose, identical laws prevailing in every branch of painting. Nevertheless, each kind of subject presents somewhat individual problems of technique, lighting, color, etc. Therefore, if the painter is to develop well-rounded skill, he should eventually try all kinds of subject matter.

I have already dealt with portrait painting; in line with the above I shall turn in this and the following chapter to the painting of flowers and other inanimate objects, all of which can be grouped under the general term "Still Life." Chapter XXI will deal with landscape.

When painting flowers from nature, an underpainting will sometimes prove impractical, because in this process there is always waiting time involved during which the underpainting must dry. Our motif may greatly change its appearance during such time. Therefore, the use of an imprimatura will here be more practical. Such an imprimatura, if it is to retain a maximum of effectiveness, must not be laid on too rough a canvas. In contra-distinction to the imprimatura used in portrait painting (a reddish or gray tone), the imprimatura for flowers may be multi-colored.

Before starting to apply the color tones, the drawing of a simple subject may be very lightly sketched directly on the canvas with charcoal or pencil, and then fixed with fixatif. (A more experienced painter will get along entirely without a drawing, since flower painting leaves one considerable latitude in arrangement of the objects.)

Now, the staining of the canvas may proceed according to a

110

preconceived plan. Strong colors, thinned with copal resin varnish
to the consistency of water color, may be used for the imprimatura.
As usual the choice of colors will depend greatly on personal
taste. Although one cannot always foresee which color will even-
tually be used, and (whether) this color will be transparent or
opaque, nevertheless it is always a good policy to choose such a
color for an imprimatura as will influence the planned top color.
Should one decide to have these final colors entirely opaque, the
stain underneath may just as well be forgotten. But should the
imprimatura find a proper utilization even on a small area, the
general appearance of a painting may, through it, be greatly
enhanced.

On our color plate shown on page 156 ("Flowers in Interior"), an
underpainting was applied to the canvas in bright yellow (cad-
mium yellow and white) all over the lower area of the painting.
The color of the upper part of the painting—that is, the back-
ground—consisted of a mixture of white and yellow ochre. The
lower part of the painting was then glazed with burnt sienna and
the upper part with viridian green, ultramarine, and burnt sienna.
Only the flowers were painted with impasto. As usual, copal
painting medium was used to thin the paint, and because much
glazing was done, the more viscous medium (known as heavy) was
chosen for this painting. Bristle and sable brushes, as well as a
palette knife were employed.

As we see, the underpainting for the flowers, in this case, was
in the nature of a toned ground, since it consisted of variations of
the same color applied to the entire canvas. Such canvases may be
prepared ahead of time because any type of flowers may be
executed upon them. Moreover, such a bright toned ground may
easily be influenced by an imprimatura if necessary.

A floral motif, in which a variety of strong colors appear in ad-
dition to green, can be very effectively executed on a yellow-toned

ground (or as the case may be, a yellow imprimatura). When painting thinly, or at least without a heavy impasto, the yellow color from within will strengthen the key of the superimposed color, adding life and brilliance to the greens.

An oil color which is too oily will not be very well suited for an imprimatura, but the excess of oil may be eliminated by spreading the color on a newspaper which will absorb the excess oil.

If we examine the floral design on Fig. 21 it will become at once apparent that painting the background around the various petals, stems, and the lace-work of leaves would be impractical. In contrast to the painting of a portrait, where the background is placed last, in painting spread-out ornaments such as flowers, it will be much more advantageous to paint the background first. The painting of a background should be executed in more or less neutral and thin colors so as not to interfere with the high hues of the motif. When brushing the background to the canvas, one may apply it all over the canvas, regardless of the pattern of the flowers, because such a thin color may easily be wiped out from the areas where it appears to be undesirable. The above implies that the background and flowers may be painted at the same time, wet-in-wet.

After the motif is painted, a modification of the background color may be attempted, if desired, without the necessity of fussing around the contours of the flowers.

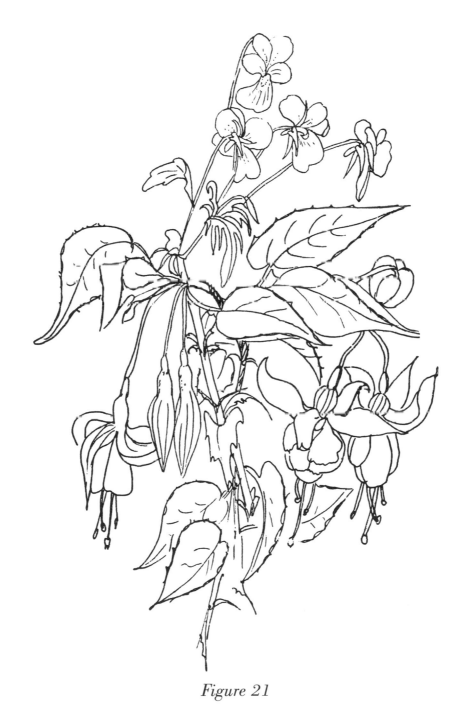

*Figure 21*

# CHAPTER XX: PAINTING STILL LIFE

ON THE FOLLOWING PAGES I shall describe the method used in painting the still life, *Violin and Trumpet,* reproduced as Color Plate 6, page 119.

In considering the plan of the painting, three factors command our attention first: composition, lighting, and colors.

## COMPOSITION

Composition is concerned with the formal relation of objects one to another. Under "formal relation" we understand the balance and harmony of masses; the logical relations of objects is entirely immaterial in considering such esthetic balance. In other words, whether the violin is composed with a fish or a trumpet is unimportant, but the abstract shapes of the objects will decide whether they function harmoniously or whether they are out of balance. Although the term "abstract shapes" sounds somewhat forbidding, its meaning is doubtless familiar to everyone—an abstract shape is precisely a geometric shape.

In starting to build up a composition, the employment of geometric forms is most useful because they eliminate immaterial details and reveal the essential construction of objects. Such a sketch may be made directly from nature—that is, directly from objects grouped into a composition—or one may plan the composition from the imagination and later make the objects fit into this pre-arranged order. The latter method is generally preferable because it gives the imagination greater latitude and freedom. In the drawing, Fig. 23, A, the construction of the composition *Violin and Trumpet* is indicated in a general geometric fashion, and at B, below, some definition of actual objects was attempted.

114

As these two drawings demonstrate, the design is developed by stages from simple and abstract pattern into more detailed and individual shapes.

## LIGHTING OF OBJECTS

Skillful lighting of a still life arrangement will add greatly to its appearance. All objects should receive the light—or be left in shade—in such a manner as to obtain a maximum of effect.

For example, I have indicated in Fig. 22 the position of a group of objects in relation to the painter and the source of light. The more the position of the painter moves from location 1 to 2 to 3, etc., the more the shadow of the objects will show and the stronger the highlights will appear. The focal intensity of the light may be increased by covering the lower part of the window with a screen (A).

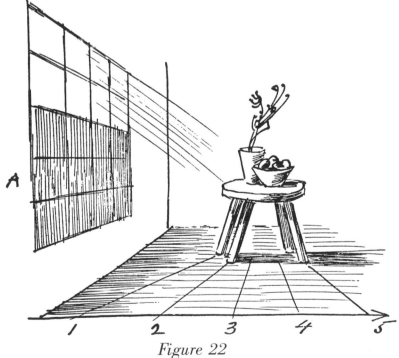

*Figure 22*

Before starting to draw, one should place one's object in various positions, moving it from one location to another (in front of the window), and placing it on a lower or a higher level until the most interesting light effect has been found.

Obviously, an object need not necessarily be lighted as here indicated. It may be placed away from the window and thus receive a dispersed instead of a focal light. A color which is not obstructed by shadows will appear in its true "local" value and hue, and the modeling of such a color will rest on subtle changes of these inherent tones. ("Local" color—a color not influenced by shades or atmospheric conditions.) Such a treatment of colors is today used by some painters of a modern school. The plasticity of objects may of course suffer when a focal light source is eliminated. In my opinion, it is dubious whether the coloristic appearance of a painting must necessarily gain by eliminating the shadow effect.

At times even the most advantageous lighting of objects might need modification in order to produce the best pictorial effects. Therefore, some light and shade effects on a painting will often have to be intensified and some will have to be subdued. For example, as demonstrated by Fig. 24,A, the uniformity of light and shade distribution on the objects is somewhat monotonous. To overcome this monotony, one may envelop some of the objects in shadow, as in Fig. 24,B.

Through such manipulation, the relevant part of a painting will receive greater emphasis because some other parts of it are subdued with shadow. Here the painter uses light and shade as the pianist uses the pedals of his instrument—for emphasis and restraint.

The shadow effects seen in Fig. 24,B, may seem to be arbitrary or artificial, but such effects will frequently be found in nature. An object placed in mid-air may cast its shadow on some part of a composition. We all have experienced such phenomena in land-

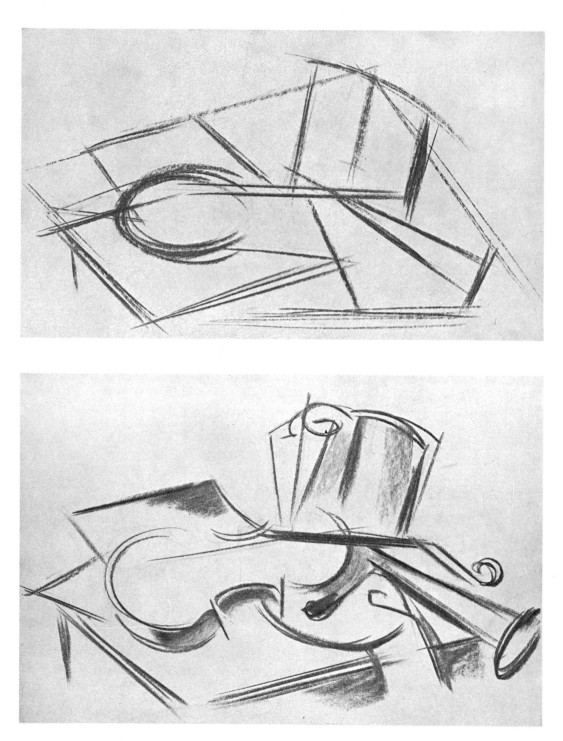

*Figure 23, A AND B*

COLOR PLATE 6—PAINTING A STILL LIFE

*Figure 24, A*

*Figure 24, B*

scapes, where passing clouds have cast their shadows on buildings, trees, or on the ground. In the city such light and shade effects are quite common, where one building casts its shadow on another. Similar effects are also observable indoors where most still life studies are made.

## UNDERPAINTING

As I have explained, the underpainting in portrait painting is plastically developed; that is, the light and shade areas are well defined. In the underpainting of a still life such as plastic treatment of objects is not necessarily sought. As seen at the top of Color Plate 6, page 119, the underpainting is entirely flat. Details and modeling are absent. Another characteristic of this underpainting is its low-keyed and light appearance.

In the choice of colors for the underpainting, the painter is led by certain definite considerations. He wishes: 1. Color which will contrast in hue with the color of the overpainting; 2. Color which is lighter in value than the color of the overpainting; 3. Color which is darker in value than the color of the overpainting (the latter choice is made when scumbling is contemplated); 4. Color which corresponds to the middle tone of the planned overpainting; 5. Color which is entirely neutral—light gray, for instance—and which is used in case no definite plan for a final color can be made.

The following colors were used in the underpainting of *Violin and Trumpet:* Background; pink (Venetian red, white). Music Sheets; gray (Prussian blue, umber, white). Trumpet; umber, Naples yellow. Cloth; pink (Venetian red, yellow ochre, white). Table; gray (umber, Prussian blue, white). Violin; umber, white. The underpainting was executed with a stiff, undiluted paint, applied with a palette knife.

## PAINTING

The palette used for completing *Violin and Trumpet* consisted of white lead, viridian green, Prussian blue, Naples yellow, yellow ochre, cadmium yellow, cadmium red, Venetian red, burnt sienna, umber, black. Copal painting medium light was used and all colors were conditioned by copal concentrate. The following colors were selected for the objects:

*Violin.* Light parts, white and yellow ochre; middle tones, burnt sienna and yellow ochre; shadows, burnt sienna and black. The painting of the violin was executed with a heavy impasto applied with bristle and flat sable brushes.

*The cloth* (*under the violin*). Black, Prussian blue, and white, moderate impasto. Flat sable brushes only.

*Music sheets.* Umber, Prussian blue, yellow ochre, white. Yellow ochre was added chiefly for reflection and middle tones. The lights were painted with considerable impasto, the reflections scumbled lightly, and the shadows show a rather thin application. Palette knife, round sable brushes, and flat bristle brushes were employed.

*Trumpet.* First a glaze of umber and cadmium was laid all over the surface. The lights were painted in pastosely with cadmium yellow and white, and the shadows deepened with burnt sienna and black.

*Background.* Naples yellow, viridian green, yellow ochre, black and white. The application of colors ranges from glazes to entirely opaque passages. The painting of the background was carried out with palette knife, and round and flat sable brushes.

*Table.* Painted in heavy impasto with yellow ochre, black, and white. First bristle brushes were used, then a blender (for blending the heavy impasto).

*The book cover* (*behind the violin*). Cadmium red and umber.

## STEP-BY-STEP PROCEDURE

After the drawing was traced to the canvas, there followed the underpainting. After the underpainting had dried well (in about two weeks), the drawing, which had become partially obliterated by the underpainting, was re-established.

The underpainting of the object to be painted—the violin in this instance—was slightly moistened with the painting medium, which is our standard procedure before starting to paint. The painting of the violin was executed in one session. As usual, first the middle tone was applied in a tentative fashion, then strengthening of the shadows followed, and, lastly, the lights were painted in and the blending and harmonization of colors was carried out. I believe it will be of interest to recount that the scroll of the violin was painted last after the background had been sketched in, because it would have been an awkward undertaking to paint the background around the somewhat fanciful form of the scroll.

Here I shall point out that the object to be painted first is the central object of the composition—in this case, the violin. The central object is the one which dominates in importance all the other elements of the composition. These other accessory elements should later be harmonized with the main theme. (The main theme of the composition need not necessarily be one single object—at times several independent motifs may be grouped together to build a main theme.)

Next the objects around the violin were painted—cloth, trumpet, table, and book. Violin-scroll, music sheets, and background were the last to be painted. Here again it seemed advantageous to treat the music sheets and the background at the same time, for the music sheets are really part of the background.

## DIVERGENT METHODS

I have described my manner of procedure in painting the still life, *Violin and Trumpet*. This is *one* good method. To be sure, there are also other ways in which it might have been painted. Let us here consider a different approach:

*The violin.* Instead of a dull underpainting (as employed in the example on Color Plate 6) which lends itself only to an opaque overpainting, we might have used a bright orange color for the underpainting. Over it a glaze of burnt sienna, strengthened with black and umber, could have been applied. The reflections, half-tones, and even the highlights, could have been derived by relieving—that is, wiping off—the wet underpainting. Of course, in this case, the underpainting under the highlights would have to be light in tone.

*The trumpet.* This could have been underpainted in Venetian red, for instance, on top of which a dark green glaze might have been used. But for highlights only cadmium yellow and white seemed to be the proper colors. Also, a bright yellow underpainting would have been suitable; such an underpainting would lend itself especially well to glazing with umber and burnt sienna.

By means of these examples, I have indicated a few methods of painting. The more experience the painter gains, the wider the fields of exploration will open to him.

# CHAPTER XXI: PAINTING A LANDSCAPE

WHEN ONE PAINTS a landscape from nature, this indicates not a mere change of locality from that of the studio to the open spaces, but a radical difference in esthetic approach. To paint out-of-doors constitutes a relatively new approach which has been in practice for only about a century. The old masters did not place their easels in the open, but they did draw out-of-doors. In fact, they indulged in the most minute study of nature, as we all know. Their technical processes of painting were, however, unsuited to be carried out while bivouacking in the open spaces. The fleeting, ever-changing effects of light and shade cannot be captured when employing a technique which necessitates a great deal of systematic preparation. Such preparation was carried out deliberately by the old masters in order to achieve some previsualized effects.

The landscapes of old masters, in other words, were not, for the most part, copies of a countryside, but they were largely inventive compositions. Even such realistic painters as Ruysdael and Hobbema did not copy nature, but they *arranged* their paintings to a great extent. The magnificent Alpine landscapes of the Flemish masters such as Brueghel, Massys, and others were not painted from nature—Flanders and the Alps are, as we are aware, geographically disconnected. This does not imply, however, that these masters relied entirely on their imagination. On the contrary, their imaginative conceptions were most certainly inspired by nature, and, as hinted above, many drawings and studies testify that these masters studied the anatomy of nature, so to speak, before embarking on the adventure of utilizing in compositions of their own invention these lessons drawn from nature.

126

When painting directly from nature, as is so often done today, one must employ a technique commensurate with the task. A working medium and method which permit quick realization of expression is here essential. The water color medium, for example, is most suitable for such a quick realization. Oil medium may also be used in a thin fashion—we see it on many Cézanne paintings—but such a technique may be carried out only on white canvas. (We also see on paintings by Cézanne that when painting directly from nature, one need not ape the color photographer and shut off one's imagination.) Impastos, heavy brush stroke, may likewise be used when painting directly from nature—some of the Impressionists painted in this manner—but here an underpainting must be entirely ruled out; the painting ground will always be white.

Painting directly from nature started with the Barbizon School a generation before the Impressionists, but it was chiefly the Impressionists who brought about the vogue of painting without preliminary underpainting, and who employed opaque painting exclusively. Among the Impressionists, Renoir was perhaps the only one who used glazes. Having been brought up as a porcelain painter, glazing was to him a familiar discipline.

Paintings from nature will as a rule have a sketchy character, since a rapid execution will normally be essential. It is conceivable that one might paint a motif in the open during a prolonged period, but to do so successfully he would have to paint under identical light conditions during each session and this would be possible only if the work were carried out in piecemeal fashion. Needless to say, under adverse climatic conditions, such a manner of painting could become very trying.

It is, however, quite important for the student to paint from nature in order to gather experience, and not necessarily with the view in mind of arriving at an accomplished pictorial statement.

If one paints in a thin fashion, the smooth surface as found on a board will be very agreeable. A pastose painting may be carried

out on a canvas with a moderate grain. I should like to repeat here that a smooth surface of the support is always advantageous when one attempts to paint minute details. A rough-grained canvas is suitable only when one paints broadly and pastosely.

## LIGHT IN A LANDSCAPE

A landscape may be lighted in any of the following ways: direct sunlight; focal light (such as that created by an opening through heavy clouds or when the sun sets on the horizon); dispersed light (as found before sunrise or after sunset, or on foggy or cloudy days).

Depending on the position of the sun, direct sunlight may be responsible for entirely different effects. As a rule, the plasticity of the objects (due to contrasting light and shade effects) decreases the higher the sun is in the sky. When on zenith, the sun creates an almost uniformly distributed light, with practically an absence of shadows. The lower the sun sets toward the horizon, the clearer becomes the division between light and shade, and the more volume the shades will gain. Under such light conditions, the plasticity of objects greatly increases. We know from experience that a landscape which appears perfectly flat and dull at noontime becomes much more interesting and plastic late in the afternoon or when lighted by a setting sun (I am not thinking here of colors but merely of the light and shade effect). Such a light was used by some of the old masters, especially by the Venetian painters of the late Baroque. This declining light creates a "romantic" mood and is widely employed by the modern Neo-Romantic painters and Surrealists. In contrast to these painters, the Impressionists used the sober sunlight of the noon hour.

As I have mentioned, the use of a focal light—that is, a concentrated source of light, other than sunlight—is generally seen on the paintings of old masters. This kind of lighting (chiaroscuro)

is still used today and is generally referred to as "studio light." Such a light affords a clear division between light and shade. A declining sun will likewise create a clear division between light and shade, but the contrasts of the light and dark areas will generally be more intensified. In nature, focal or studio light effects are rarely encountered, but an opening in heavy clouds will create such a light condition.

Dispersed light—that is, diffused or scattered light, in contradistinction to focal light—has been used by the so-called Primitives, in paintings of the pre-Renaissance era. This means of lighting, for centuries practically given up, was again favored by some nineteenth and twentieth century painters.

## POINT OF OBSERVATION

A landscape may be viewed from different points of observation. For example, one may view it from a low vantage point or from a high elevation. Fig. 25 demonstrates this, as it shows the same objects viewed from below, from the eye level, and from above.

In landscape composition, the choice of the point of observation is of great importance, since the interest of a landscape may greatly depend on the angle from which it is viewed. This angle will establish the relation between the mass of the sky and the ground. The expanse of a sky will be largest when the landscape is viewed from a low vantage point, and the sky will take the least area when it is viewed from a high elevation; that is, from a bird's-eye view. All these considerations should be taken into account when one composes a landscape.

## LINEAR PERSPECTIVE

When we speak of perspective in a landscape, we refer to the depth of a picture. Composition, as well as color and atmospheric

A. Geometric Objects Above the Eye (Worm's eye View)
(Horizontal lines appear to slope downward toward eye level)

B. Geometric Objects at Eye Level (Normal View)

C. Geometric Objects Below Eye (Bird's eye View)
(Horizontal lines appear to slope upward toward eye level)

Figure 25

conditions, may create this depth. When using linear means, convergence of receding parallel lines and decrease in volume of objects as they become more distant will create a sensation of depth. (See Fig. 26.) The more emphasis is put on the decrease of the volumes in space, and the more rapidly the parallel lines converge to a focal point on the horizon, the keener the sense of perspective becomes.

To create a sensation of distance—to push, so to speak, the plane of the painting into the background—an old device has been used for centuries and is still used today. This device is to place some large object or objects directly in the foreground of the picture. (See Fig. 27.)

*Figure 26*

Such devices have become, in time, rather stereotyped, but they have not been replaced by any new devices, nor are they likely ever to be replaced. The reason for this is that they are based on the immutable laws of scientific perspective. Differences of style may have brought about some minor variations in the treatment of perspective, but the principles of spatial arrangements have remained the same since they were generally adopted in European paintings more than five hundred years ago.

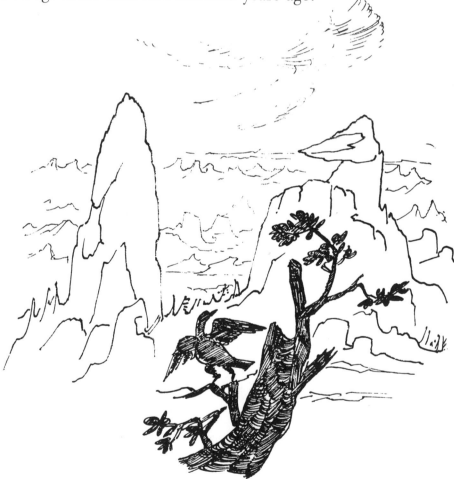

*Figure 27*

What I have described above pertains to the "scientific" conception of perspective. To be sure, there are other conceptions which do not conform to the laws of science. The so-called Primitives did not rely on realistic canons of perspective, and many of the moderns, deriving their knowledge from Cézanne's methods, do not favor scientific perspective. I, for my part, believe that the composition of a painting may be greatly enhanced when one "conditions" the perspective according to his artistic needs.

## ATMOSPHERIC PERSPECTIVE

In addition to "linear" perspective, we have what is known as "atmospheric" or "aerial" perspective. This is a kind of perspective due in part to the nature of the human eye, but to a greater extent to the blanket of atmosphere with which the earth is enshrouded.

If, by way of demonstration, a landscape feature is moved gradually from the foreground to the middle ground and then to the background—an effect which we sometimes gain from the observation platform of a moving railway train—we observe that as the distance between the eye and the object increases, certain changes in its appearance take place, entirely aside from those pertaining to linear perspective.

Its color, for example, seems to become less brilliant with every rod of increased distance. As I mentioned before, a color which is uninfluenced by shade or by distance, is known as a "local" color. A barn of red local color—or of any other strong hue, for that matter—will grow less red in effect as it becomes more distant from the eye. It may actually appear bluish when removed to the far background, due primarily to the moisture which will veil it. The greater the atmospheric dampness, the more vague in hue will it appear.

Its plastic appearance, too, will be modified, differences of light and dark becoming less marked with increased distance. An object which, in the foreground, exhibits strong contrasts of light and shade, giving it an interesting effect of roundness, may, in the distance, appear almost flat, its dark values seeming lighter and its light values darker as the atmosphere veils the whole. Not only will the object's color and its values thus be softened, but its contours will become fuzzy in the distance, no matter how sharp they may be if viewed from near at hand.

Now, how much of all of this aerial perspective is the painter to utilize in his painting? Is he going to paint everything in the foreground sharp in focus and strong in color just because he can see it so in nature? And shall he make everything in the distance blurry in value and edge, and dulled in hue?

Not at all. So far as differences in effect due to atmospheric conditions are concerned—and these are major ones—he subjects them to his own control. We have all observed a misty, faded, blurred appearance of mountains in summertime, so characteristic of Southern California, for example. But in winter, these mountains appear clear, sharply contoured, and much closer to the eye. If the artist understands such effects, he can utilize the one which best serves his purpose.

## EMPHASIS AND SUBORDINATION

In other words, the artist feels free to focus attention wherever he wishes in his painting by using in that area the most interesting subject material, the strongest hues or value contrasts, the sharpest contours, or the most fully treated detail. Wherever he wishes to subordinate, he does so, softening edges, blurring colors, blending tones. He may sometimes choose to focus attention in the distance; again, in the middle distance; yet again, in the fore-

ground. To repeat, once he has mastered the principles—and this he does by studying nature—they are his to command.

Stating some of this differently, although we have established the fact that a bluish, misty color is characteristic of distance, we may on certain occasions paint distant objects in the local colors in order to emphasize their importance and dramatize their effects. For the same reason, an atmospheric color, which we expect to find in the distance, may be used in the foreground. This illustrates again that it is more the painter's ingenuity which makes a landscape convincing than a set of practical rules.

## COLOR DISPOSITION

When painting a landscape in the studio, whether from a drawing, a color sketch, or the imagination, it is well to employ an underpainting in order to achieve a maximum of pictorial effects. I have not found an imprimatura application to be quite practical in landscape painting except when used on small areas. Although the color of the underpainting may be entirely hidden under the final paint layer, one should always presuppose that a utilization of the underpainting will take place. In spite of all calculations, even an experienced painter may not always be able to pre-visualize the final effects of a painting. However, when underpainting is kept in very light tones, greatest latitude in its utilization will offer itself.

## LANDSCAPE, ANALYSIS OF COLORS

Turning now to our illustrations, Color Plate 7, page 137, the following colors were used for the underpainting of *Wilderness,* at the left:

*Sky.* Pink (Venetian red and white).

*Background and middle ground.* Naples yellow and white.

*The rocks.* Yellow ochre and white.

*Foreground.* A cadmium yellow imprimatura.

*Rock in the right hand corner.* Yellow ochre and white. Executed with palette knife.

The following colors were used for the overpainting (right):

*Sky.* Prussian blue, black, Naples yellow, white. Painted with palette knife, round and flat sable brushes, and bristle brushes.

*Background* (*the distant mountains*). White, viridian green, Venetian red, Naples yellow. Round sable brushes.

*Middle ground.* Prussian blue, yellow ochre, burnt sienna, white. Round sable brushes.

*Rocks.* Glaze of umber and burnt sienna, applied with palette knife. The rock structure delineated with round sable brushes.

*Trees and bushes* (*in the middle ground*). Burnt sienna, Prussian blue, umber, cadmium orange. Round sable brushes.

*Foreground.* A glaze of viridian green and cadmium yellow, applied with bristle brush.

*Rock in the foreground* (*right hand*). Cadmium yellow, Prussian blue, burnt sienna, applied with the palette knife.

The painting medium used was stand oil, three parts; damar picture varnish, one part.

## PROCEDURE

When painting a landscape, it will usually prove to be a good rule to start on the remotest plane of the picture—that is, on the background—and to proceed painting toward the foreground. The reason is a purely technical one as demonstrated on Fig. 27. This procedure contrasts with the method demonstrated on the painting, *Violin and Trumpet,* where the main object of the composition was the first to be handled.

COLOR PLATE 7—PAINTING A LANDSCAPE

In looking at the graph of the landscape composition, *Wilderness* (Fig. 27), which I complicated by adding a foreground very close to the beholder, it becomes at once apparent that if this foreground were painted first, the middle ground would have to be painted around the contours of the foreground, and this would entail serious difficulties. Similarly, if the rocks were painted before the background, the latter would have to be painted around the contours of the rocks. In order to circumvent such difficulty, the background should be painted first. Of course, modifications of color and design may be carried out later on all parts of the painting.

Another important principle is to paint the sky last, as is the case in painting a background in a portrait. Should the sky be the dominant part of the picture, however, and subordinate all the other elements of the composition, it may be painted first. As a rule, the sky should emphasize the mood of a landscape, or we may say as well that the landscape should dictate the character of the sky.

# CHAPTER XXII: CORRECTING A DRY PAINTING

AFTER A PAINTING has been finished, whatever the subject matter, one will often experience the need for some improvements in color or design. At this point the painting may be either superficially or totally dry.

A semi-dry paint film—that is, a film which is dry only on the surface—should not be overpainted. Any injury to a paint film which rests on a soft paint layer would produce either wrinkles or unpleasant scars of the paint film, or it would cause cracking of the overpainting.

In order to ascertain whether the paint film has dried throughout, one should press a fingernail into it. When a moderate pressure will not leave any appreciable mark on the paint film, one may proceed safely with the overpainting. But first, the following manipulations will have to be carried out: Pastose brush marks and paint applications should be scraped off with a scraper and then, if need be, sandpapered with a medium smooth sandpaper. The sandpaper should be used in parallel and horizontal strokes, rather than vertical or circular ones. Next, retouching varnish should be applied, and in a few minutes the painting medium may be rubbed into the surface preparatory to overpainting.

The chief difficulty which will now face the painter is the treatment of the newly created contours—that is, the border lines between the fresh paint application and the dry paint surface. In order to blend the new border line into the old, the brush should be "dragged" over the dry painting. "Dragging the brush" is the expression used when one moves a semi-dry brush along the canvas. A brush which does not carry enough paint will cover only the top grain of the canvas with the color, and thus it will produce

*Figure 28*

a stroke of a fuzzy appearance and create soft transitions, as in the lower example, Fig. 28. The clean-cut stroke in the upper example was executed with a loaded brush.

Sometimes a transition may be effected by blurring the wet color with the finger. Should a contour, however, require a thorough blending, the above-described half-measures will not suffice. A thorough blending can take place only when both adjoining paint areas are wet. In order to create such a condition, one will have to overpaint the surface adjoining the new paint application, as illustrated in Fig. 29. Blending of wet colors may now proceed and any desired degree of softness of the contours may be achieved.

The removal of any undesired part of a paint film may be effected with a paint solvent as described on page 31. When used with great care, a mild paint solvent may gradually remove the over-painting and eventually re-establish the original underpainting. Should this underpainting become obliterated for one reason or another, however, it may be re-painted in areas where it appears desirable. After this new underpainting dries, it will be ready to be overpainted in the usual manner.

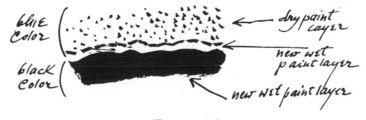

*Figure 29*

# CHAPTER XXIII: HOW TO OVERPAINT AN OLD CANVAS

OLD, DISCARDED PAINTINGS may be used again for painting. A painting which does not show impasto or heavy brush strokes—in other words, a thinly executed painting—should first be rubbed with a mild solvent in order to remove the oil film from its surface. Next, retouching varnish should be applied to it, whereupon a new white lead ground may be spread on it thinly with a palette knife.

Dents on a canvas, such as created by pressure of a sharp object against it, may be flattened out by moistening the reverse side slightly with water.

In case a ground of a rougher texture is desired, the white lead color (of the canned variety) may be applied with a bristle or a house painters' brush, and then the heavy marks of the brush should be smoothed with a flat sable brush or a blender. It is advisable to use the brushes crosswise. That is, if one kind of brush were moved in a horizontal direction, the other should be moved in a vertical direction.

Old paintings which show a heavy impasto should first be treated with a medium coarse sandpaper. After all the textural roughness has been removed, retouching varnish should be applied to the surface (this is always done to promote a better adhesion of the following ground) and a new ground of white lead applied on top of it with a palette knife or brushes as described above. One should permit the ground to dry well before starting to paint on it. A thin ground will be sufficiently dry in about a week. A heavy paint layer may take considerably longer.

Another way of reclaiming an old canvas is to use its reverse

side. This procedure is quite simple and can be carried out by an inexperienced painter. The old canvas should be taken off the stretcher and nailed on it again with the reverse side up. Next, half an ounce of common household gelatin should be dissolved in ten ounces of hot water and, when cool, the jellified substance should be spread thinly on the canvas with palette knife like butter on a slice of bread. When the gelatin solidifies, which takes place in a few hours, a new white lead ground may be applied on it in the manner described on page 16. A canvas prepared in this fashion is in some respects preferable to a new one.

# CHAPTER XXIV: HOW TO CLEAN AND VARNISH PAINTINGS

IT MIGHT SEEM LIKE an oversimplification when I say that after dusting a paint surface with a soft cloth, the remaining dirt clinging to the surface can be largely removed by rubbing the surface with one's fingers. In doing so, note how dirty the fingers can become in some instances; hands may require repeated washing before all the dirt is wiped off the surface. However, there are tougher cases in which old varnish as well as dirt will have to be removed. Retouching varnish and damar picture varnish yield easily when the paint film is rubbed gently with a piece of surgical cotton moistened with a solvent known as painters' thinner, obtainable in every hardware store.

## VARNISHING

Before varnishing, one should take care that the surface of the painting is entirely free of the cleaning medium. Any moisture left on the painting may cause the varnish to become cloudy and spotty. Therefore, one should permit about one hour to elapse between cleaning and varnishing.

As already mentioned, a painting may be well dry in from two to six months, depending on the thickness of the paint film, and providing one employs the technique and materials recommended in this book. The danger of cracking when varnishing a painting prematurely is nonexistent.

The painting to be varnished may be placed horizontally on a table or vertically on an easel; in either case the position of the

144

painter should be such as to permit him to see clearly the gloss of the varnish as it spreads over the surface of a painting. Only when watching the process of varnishing from an angle where the gloss may be well controlled, is an even distribution of the varnish possible. In order to avoid too heavy a coating of the paint surface, the varnish should not be put on with a fully loaded brush. Two thin coats of varnish are better than one heavy coat. Should one single varnishing fail to impart sufficient gloss to the painting, another coat of varnish may follow in twelve to twenty-four hours after the first.

A paint surface which has fairly hardened may be varnished with any bristle brush. Also the common house painters' brush is well suited for this purpose. However, when a painting has not dried well, it may easily be injured by the softening action of the retouching varnish, especially when a harsh brush is used for its distribution. Therefore, it will be more appropriate to use on such paintings the soft sable brush.

Since the final picture varnish is used on well-dried paintings, it will be distributed with a bristle brush exclusively. Here the use of the house painters' brush is also recommended. Depending upon the size of the painting, the brush may be from three-quarters of an inch to two inches wide. The older such a brush becomes, and the fuzzier the hair, the better it is for varnishing—providing it does not shed hair.

A painting that has dried for at least one year, especially when it is a large painting, can be very well varnished with a cheese-cloth. When slightly moistened by the varnish, the cloth produces a thin, even varnish film, which also picks up dirt embedded in the paint texture. In fact, the cheesecloth cleans and varnishes a painting in the same operation.

When a light gloss on a painting is undesirable, a mat varnish

can be employed. My own formula (Permanent Pigments) produces a satiny finish, equalizing the often uneven appearance of gloss on the glazes and impasti.

Lastly, it should be affirmed that spraying varnish from pressure cans is entirely inappropriate, because it does not produce a desirable varnish film for an oil painting.

# GALLERY OF EXAMPLES

SUZANNA     *This small sketch (12 x 16 inches) was executed chiefly with round sable brushes and a palette knife. One can see the effects of the sable brush in the draftsman-like demarcations appearing primarily in the background, but also in the figure. Private Collection.*

148

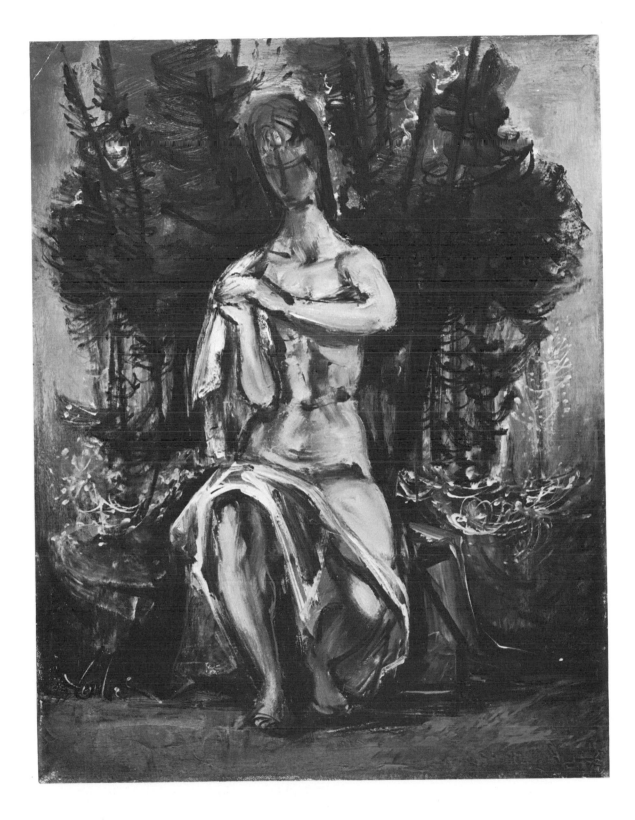

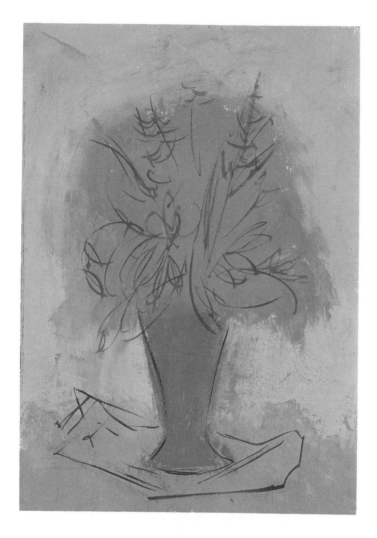

THE RED VASE    *Underpainting for flowers is quite simple, for our first concern is to have our final colors appear in a high key. Which underlying color will make the superimposed color appear most brilliant? The answer is simple: a strong yellow. Hence, regardless of the final color of the particular flower, the entire area of the bouquet is underpainted in yellow. The background carried a pale green-blue underpainting—viridian green and white—and the red vase was, for the sake of contrast, underpainted in a dull green mixed from black, yellow, and white.*

   *In the final painting, cadmium yellow, cadmium red, alizarin crimson were used for the flowers; cadmium yellow and ultramarine for the greens. The background was painted in a bluish green—ultramarine blue, viridian, and white.*

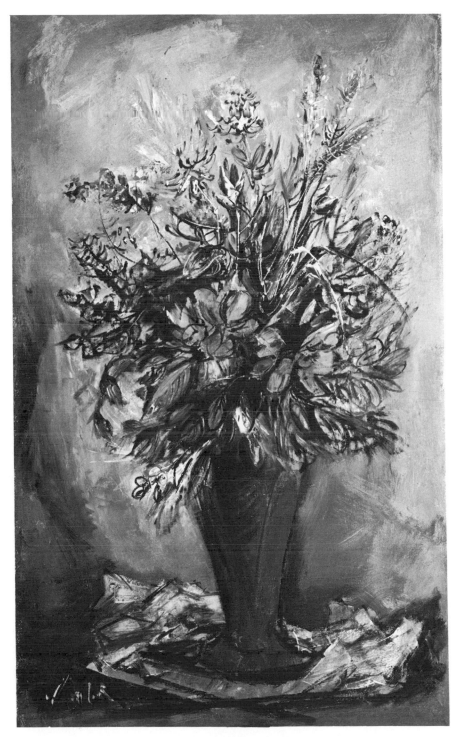

151

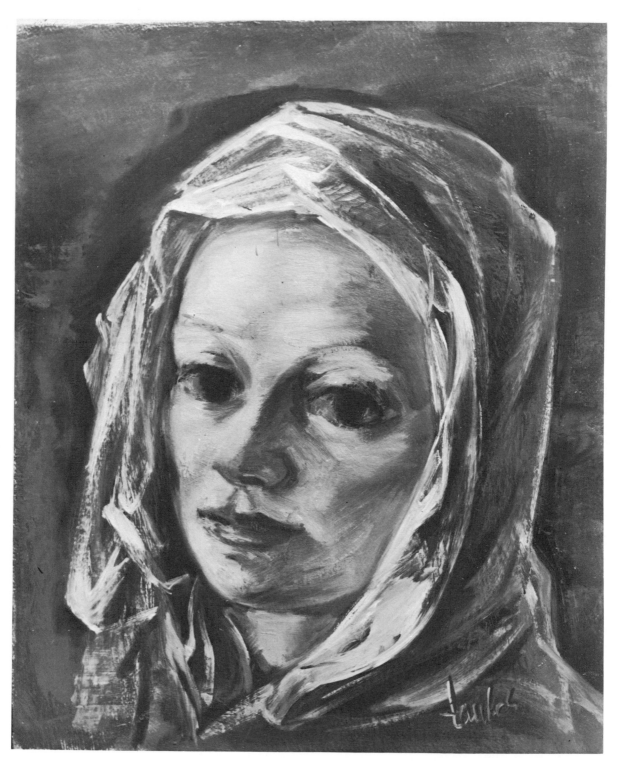

152

HEAD WITH VEIL     *In this instance, glazes are entirely absent. However, scumbles appear in profusion, most prominantly in the area of the veil. In fact, the reason for painting the veil was to exploit the charming effects of scumble. When painting with a light (wet) color into a dark (wet) color, the viscosity of paint becomes essential. Hence, the white color was conditioned by a relatively larger quantity of the copal concentrate.*

*Because of the rather monochromatic appearance and the opacity of the study, I executed the entire underpainting in monotones; that is, in grays. These grays can have a warm or cold tonality; they can be mixed from umber and white, or Prussian blue and white. Also, ochre or Venetian red can be added for the sake of variation.*

THE ROCK *(Underpainting)*     *On this underpainting, the principle of a sensible technique is exemplified: transparency requires lightness that should become active from within, from the lower layers of the paint stratum. Hence, the areas that were to receive glazes were underpainted in a light color. In contrast, the areas that appear dark in the underpainting will eventually receive a light impasto. One must employ the light color with impasto—stronger or lesser impasto, according to the occasion and, of course, one's preference. The reason for the impasto is simple: to be effective, white paint must be used with appreciable thickness; that is, without diluting much with the medium.*

*When one works on a canvas, the knife is the best tool for executing an underpainting, because it forces the paint into the interstices of the fabric, thus allowing the brush to move over the surface without impediment.*

154

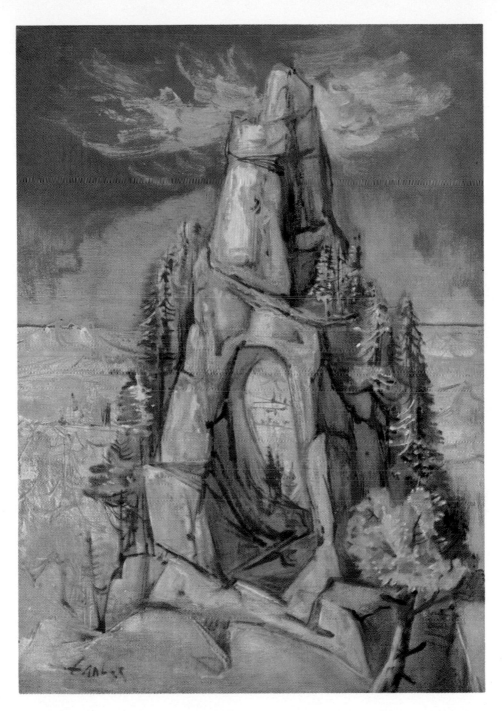

THE ROCK  *Because of the small format (18 x 12¾ inches), a rather fine-grained canvas was chosen, and only one layer of white lead priming was applied. With the exception of the sky, which was underpainted in pink (Venetian red and white), and the light part of the rock (underpainted in a darker color), all areas received a yellow color which varies in hue depending on the objects and their position in space. Thus, the distant objects appear pale, while the foreground areas were treated with strong yellow. In this painting, glazes predominate; hence, there is a great deal of transparency in the treatment of the surface.*

**FLOWERS IN INTERIOR**     *The flowers in the foreground were painted freely, in fluid color, with impasto accents. The rhythmic lines and darker accents were painted with round sable brushes, which produce a sensitive calligraphic line. The over-all tone of the background is a glowing glaze of burnt sienna, which washes over the table top. Cooler tones strike through the warm glaze to create the varied textures of the wall and table.*

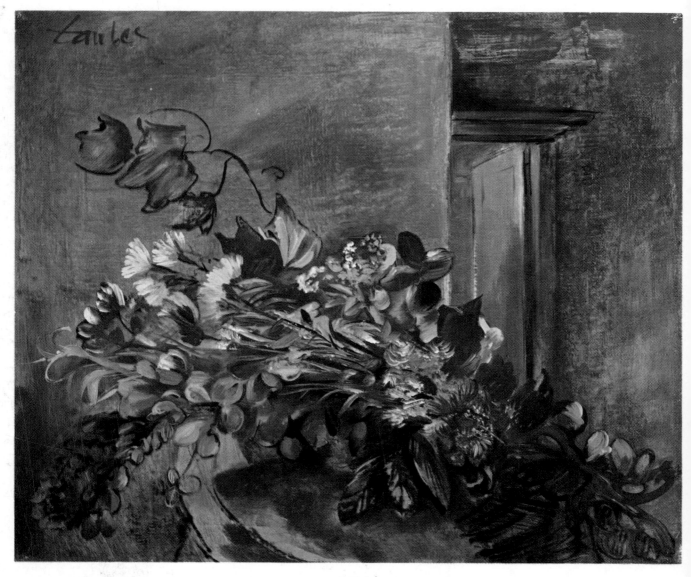

THE ROCK AND THE PLAIN    *This is a 12 x 14 inch alla prima painting on a canvas carrying two white primings and one priming in ochre and white. Hence, the remaining tooth of the fabric was extremely fine. Here, as in the "The Rock," the part in the shade was glazed, and the one in light shows strong impasto. I scumbled the impasto into a dark glaze (umber and Prussian blue) with a palette knife. All the details were painted with a small round sable brush. Private Collection.*

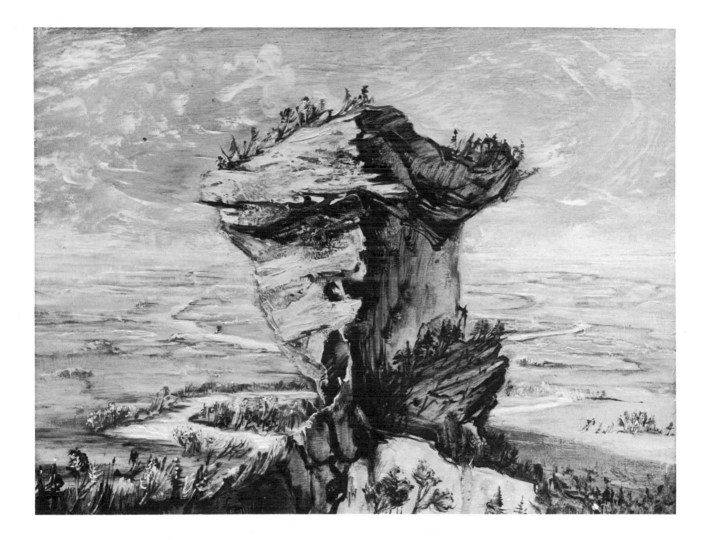

THE FOUR SEASONS   NUMBER ONE SPRING LANDSCAPE       *These three panels are part of a quadriptych hinged together and representing the Four Seasons. Each of the panels is 20 x 40 inches and together they form a surface of 80 x 40 inches. All were executed in the traditional manner, starting with a very light underpainting and a second underpainting a little higher in key, but still relating to the finished painting as a kind of "understatement." In the underpaintings, the sky area of all the panels was pink and the ground varied in yellow hue. In the distance, this yellow was dull, and low in key; in the foreground, it was more lively. In the final painting the presence of this yellow makes itself felt by imparting luminosity to the greens. Private Collection.*

158

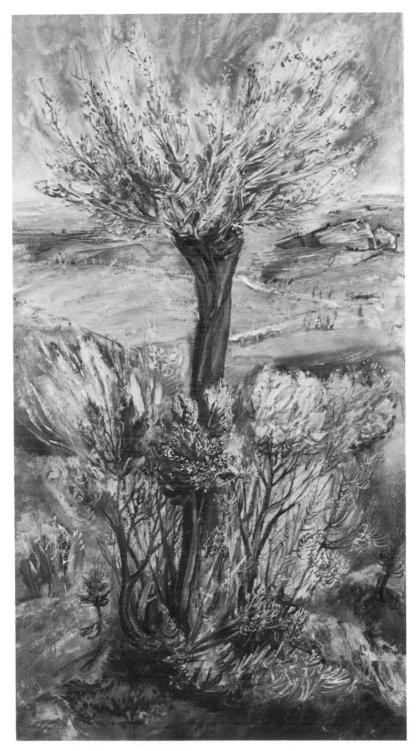

159

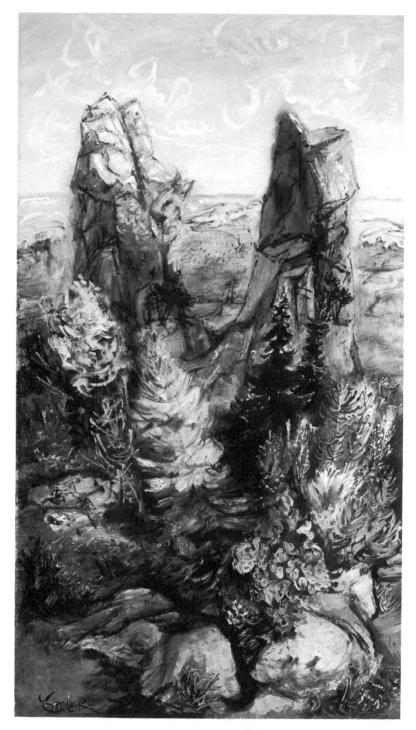

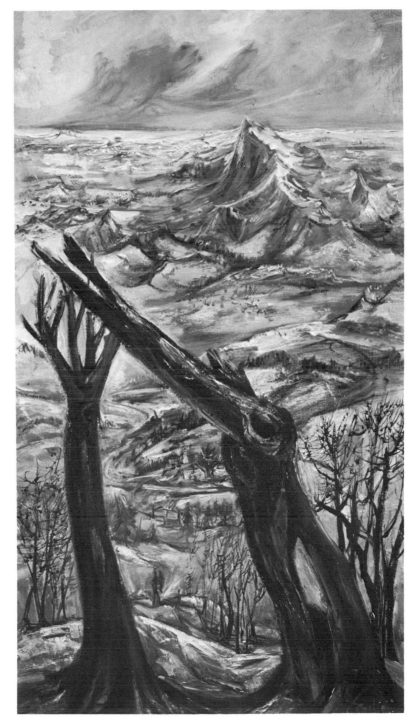

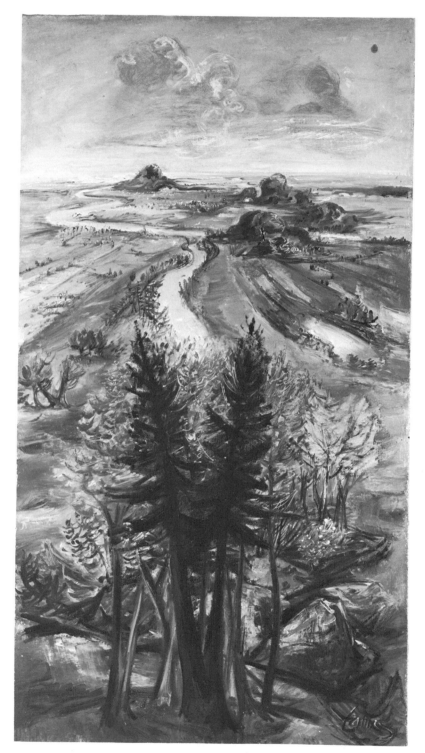

162

AUTUMN LANDSCAPE    *I painted this on a relatively large canvas (24 x 46 inches); hence, the coarse-grained fabric received two layers of priming, and two underpaintings. The first was paler; the second showed stronger colors, of a more or less similar domination. I underpainted the sky in a pale pink; the area of the ground carried a pale gray-yellow in the background that became higher in key as it moved into the foreground. The entire area of the trees in the foreground was underpainted with cadmium yellow and white.*

*The following colors were used for final painting (beginning with the sky area): ultramarine blue, viridian green, Naples yellow, white. In the distant ground, I used the same colors, but less ultramarine and white. Burnt sienna mixed with viridian was added for strong accents. Ochre, raw sienna and viridian entered into the middle ground; cadmium yellow, Prussian blue and burnt sienna for the foreground and for the darkest definitions.*

163

LANDSCAPE WITH TREE STUMPS    *The size of this painting is only 8 x 10 inches,*
*very small for an oil painting. Hence, I only used round sable brushes. The*
*canvas had very little tooth left. It carried a toned ground of ochre and white,*
*and the painting was executed alla prima.*

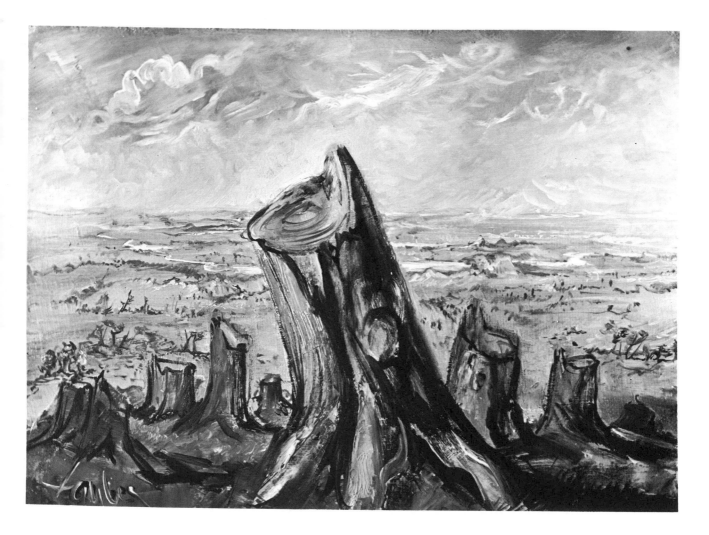

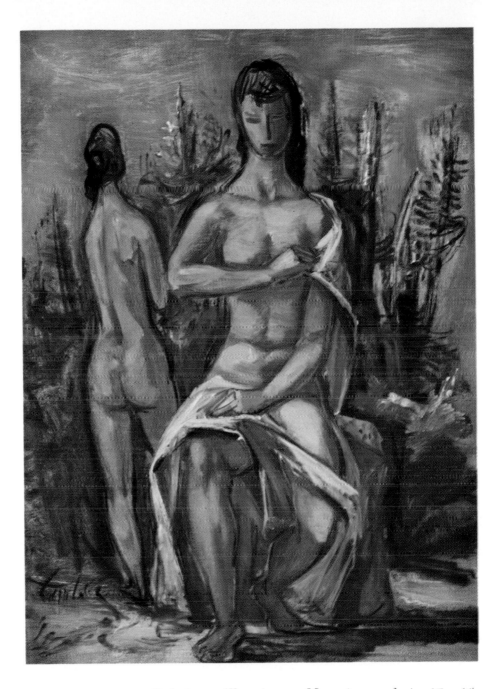

NUDES IN LANDSCAPE     *Technique: Alla prima on Masonite panel, size 12 x 16. The panel carries a gesso ground and a multicolored imprimatura. Under the sky area and the flesh part, I used burnt sienna; in the background cadmium yellow and in the foreground ochre. Copal varnish served for thinning these colors. After allowing the imprimatura to solidify (this takes at least two days), the final painting was executed with the following colors: umber, Venetian red, burnt sienna, ochre, cadmium yellow, Prussian blue, viridian green. Because all colors were conditioned by copal concentrate, and because no overpaints followed (as is the usual procedure when underpainting is used), the paint dried with a good gloss. Hence, no varnishing was required.*

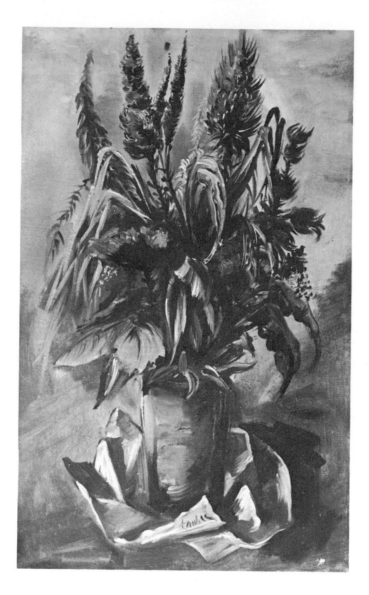

**FIELD FLOWERS**      *The small fine-textured canvas (12 x 18 inches) has an underpainting in two colors; yellow (cadmium yellow and white) under the flowers, and ultramarine and white (of a very light hue) under the background. I did the painting in one operation, that is, de facto alla prima. But because I used a canvas here, not a panel, I applied the paint with considerably more impasto. Hence, the glazes do not predominate as they do on a gessoed Masonite panel. Private Collection.*

166

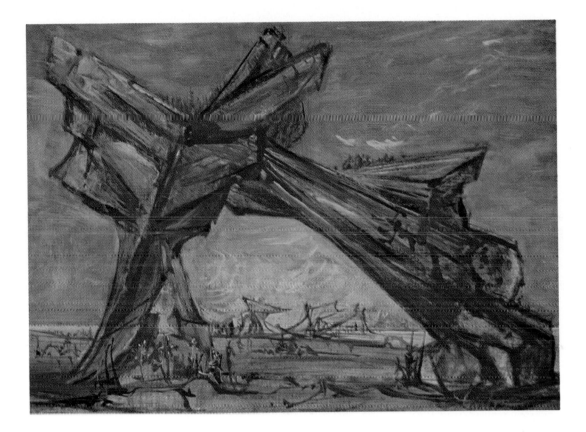

STONE BRIDGE      *Technique: Alla prima on a Masonite panel 11 x 15 inches. The panel carries a gesso ground upon which a multicolored imprimatura was applied. In the area of the sky — burnt sienna; under the rock—ochre; and on the ground—viridian green and ochre were employed. I thinned these colors with copal varnish. The following colors were used for the painting: umber, burnt sienna, ochre, Prussian blue, viridian green, white.*

*It should be emphasized that, when using the traditional technique and materials, alla prima paintings will not require varnishing for protection, or for re-establishing the original gloss, because alla prima paintings dry with a smooth, nonporous surface.*

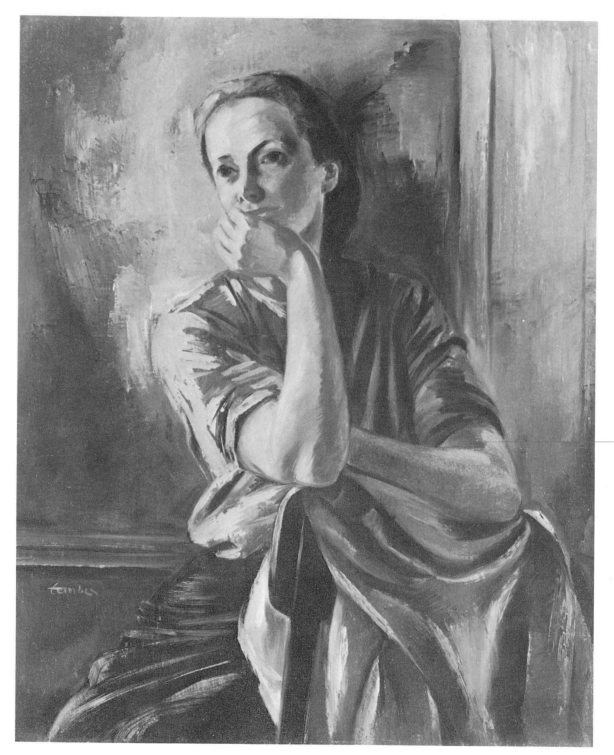

168

LILI    *This painting was done in a "classic" manner on a traditional under-painting: a light grisaille under the flesh parts and contrasting colors for the rest of the canvas. For example, the red blouse was underpainted in green, and the blue-green background in a light pink.*

*This being a figure composition, I stressed the movement of the body. Movement and countermovement are expressed in the position of the arms, the opposing turn of the head and the body, and the direction of the folds. These folds emphasize and support the movement of the arms and the body. Courtesy the Metropolitan Museum of Art, George A. Hearn Fund, 1939.*

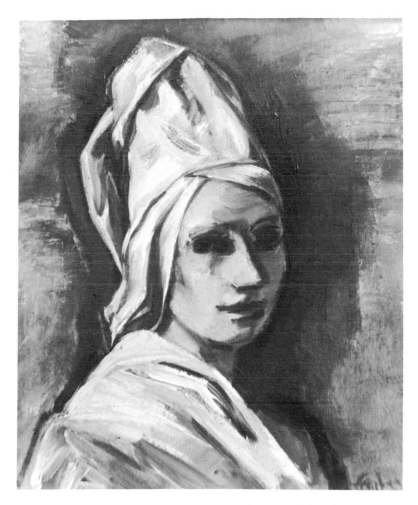

THE PINK TURBAN    *The size of this canvas is 16 x 20 inches, and the characteristics of the painting are the rather heavy impasti throughout the entire surface. As usual, I painted the background with a palette knife, and its horizontal marks are clearly visible on the left side and the upper right side. Private Collection.*

169

ROMANTIC LANDSCAPE     *The rock carries heavy underpaintings—light in the area of the shadow, and dark in the area of the light. The first surface was painted very smoothly, the second had a rough texture. The part in shadow was glazed with umber and Prussian blue, and the light part was overpainted with a palette knife, a method which produced the characteristic texture of the impasto applied on top of the rough underpainting. Scumbles produced with the knife also appear in the foreground. The canvas is 16 x 24 inches. Private Collection.*

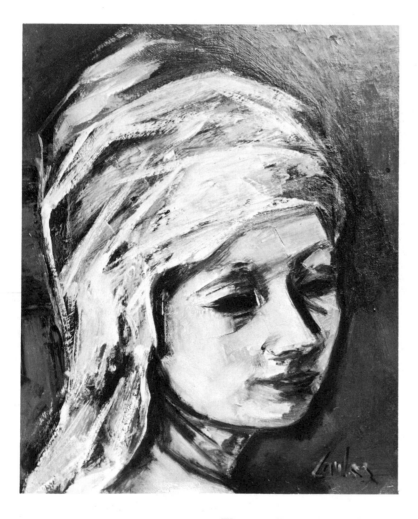

HEAD WITH TURBAN     *This small canvas (10 x 12 inches) carries very heavy impasti which were produced by at least six overpaints. Here, much knife work is seen in the area of the face and the background. The headgear shows heavy scumbles produced with a large sable brush. Private Collection.*

170

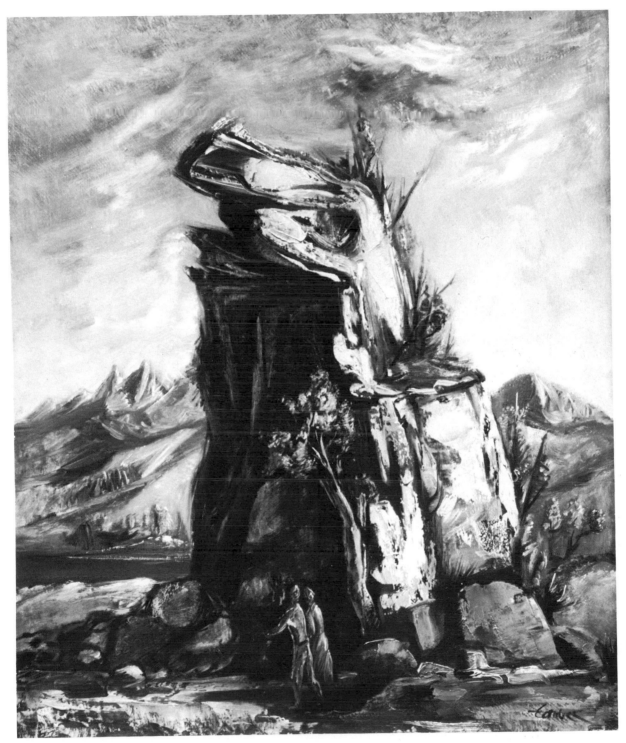

171

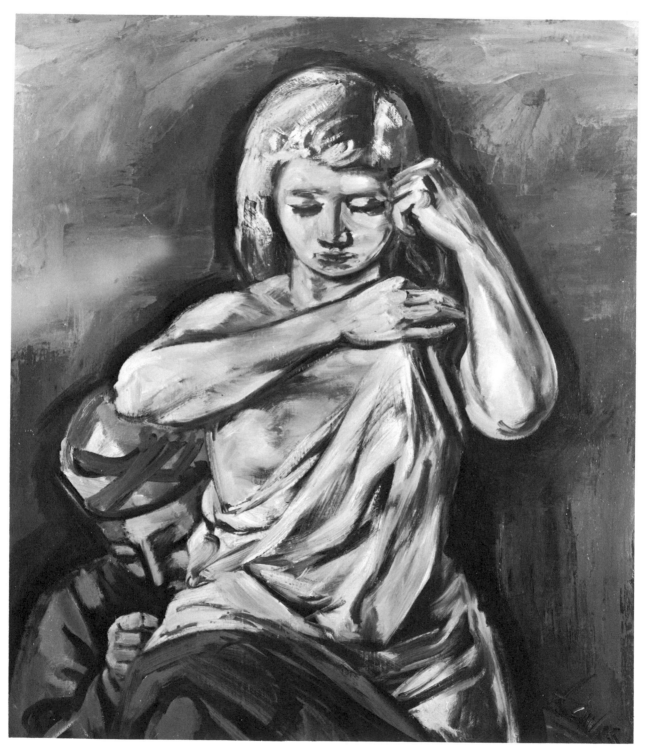

172

BATHESHEBA    *The painting, just under life-size (on a canvas of 20 x 30 inches), is opaque throughout, and carried out in heavy impasti. Under the final painting, two underpaintings are hidden. There are also two paintings, which cannot very well be considered purposeful "underpaintings," for in this instance these were merely unsatisfactory "final" paintings that had to be amended.*

*In this figure composition, I emphasized the rhythmic organization of the "directional" lines, which are firmly imbedded in the dresses of the figures. The movement and the countermovement of the arms, contrasting strongly with the frontal and rather static position of the body, serves the same purpose: they stress the rhythmic sequences that pervade the entire composition. Private Collection.*

173

# INDEX